DRAWING DYNAMIC HANDS

DRAWING DYNAMIC HANDS

BY BURNE HOGARTH

WATSON-GUPTILL PUBLICATIONS/NEW YORK
PITMAN PUBLISHING/LONDON

First published 1977 in New York by Watson-Guptill Publications,
a division of Billboard Publications, Inc.,
1515 Broadway, New York, N.Y. 10036

Library of Congress Cataloging in Publication Data
Hogarth, Burne.
 Drawing dynamic hands.
 Bibliography: p.
 Includes index.
 1. Hand in art. 2. Drawing—Instruction. I. Title.
NC774.H63 1977 743'.49 76-50016
ISBN 0-8230-1367-7

Published in Great Britain by Sir Isaac Pitman & Sons Ltd.
39 Parker Street, London WC2B 5PB
ISBN 0-273-01049-2

Manufactured in U.S.A.

First printing, 1977

To TODROS GELLER—
artist, friend, inspired teacher—
whose name deserves to be remembered.

ACKNOWLEDGMENTS

I would like to express my thanks and appreciation to the three persons who are mainly responsible for resolving the physical elements of this book. I owe a debt of gratitude to Donald Holden, Editorial Director of Watson-Guptill, who was there from the very beginning and guided it through to the end; to Connie Buckley, Editor, who had the hard job of working out the wrinkles and putting the material into comprehensible form; and to Robert Fillie, Designer, who produced an excellent design and layout.

CONTENTS

INTRODUCTION

It is an ancient precept that the person who would be an artist must first learn to *draw*. Anyone who has ever wished to become an artist—who has taken those first faltering steps down the road to art—has begun with the desire to draw. It was the love of drawing that confirmed all those initial hopes. And through all the later aspirations, as long as the creative drive flourished, the urge to draw never died.

Those of us who are committed to working in the visual arts can remember our first formal training. When we first enrolled in a studio art class—whether our goal was painting or sculpture, illustration or design—we knew that *drawing* had to come first. Our first adventure in art began in a drawing class. Drawing, we knew without doubt, was the root of the visual image and the core of all art experience.

It is safe to say that there is no system of education for the artist that does not offer drawing—indeed would not *dare* offer a curriculum without drawing. The visualizing capability would be crippled. And if we have reason to examine a student's portfolio to assess performance and potential talent, there is no firmer touchstone than the quality of the drawing.

Learning to draw means, a priori, *figure drawing*. If we say, "Here is an artist who can draw," we mean that this artist can draw the *figure*. But now a subtle distinction emerges. Among the world's artists schooled in the figure, who are the most noteworthy, who are those of the highest rank—and how do we know them? The transcendent artists were those who could draw the most difficult of all figural elements, the *human hand,* with authority and authenticity. And these tended to become the luminary creators.

Consider the poignant hands and form in the *Expulsion* by Masaccio; the ago-

nized hands of Grünewald's *Crucifixion*; the graciousness of Botticelli's *Adoration*; or the infallible simplicity of Dürer's *Praying Hands*.

Can anyone doubt the harmony, the perfection of forms in the figures and hands in the works of Leonardo, Michelangelo, El Greco, Rubens, Velasquez, Caravaggio, Rembrandt. . . .

Do we in our time support the canon of the figure and the criterion of the human hand? Does anyone doubt the competence of Matisse, Rouault, Braque, or Picasso to create art from the springboard of the figure? And how shall we understand Rodin in the tortured *Burghers of Calais* or the brooding *Thinker* if not by their hands?

Let us venture, speculatively, one last proposal. In all the world's art, the highest inspirations, the most lofty visual expressions center around the hand. From the earliest hands of the Aurignacian hunter to the majestic God-king of Egypt, the hand speaks to us. The hand spells resistance to tyranny and proclaims victory in the statue of *Harmodius and Aristogeiton,* the heroes of the world's first democracy. The hand of Adam receives the spark of life in Michelangelo's Sistine ceiling. The hand holds aloft the chilling form of Medusa's head in Cellini's *Perseus*. The hand of Bologna's *Mercury* leads our thoughts skyward.

The hand, as Rodin showed us, is the alter ego of mankind, *The Hand of God*.

But it is also the hand of that other creator, the artist, who, shaping the hand, creates himself.

BURNE HOGARTH
Pleasantville, New York
December 1976

1.
FORMS AND STRUCTURES

The hand is not a flat, two-dimensional shape without volume. It is a dynamic, three-dimensional body form, energetic and complex, each of its forms and structures interrelated. In this chapter we will look at it from various angles in space and depth, noting its curves and rhythms and examining the bulk, sizes, shapes, and masses of its individual parts and their relation to the whole.

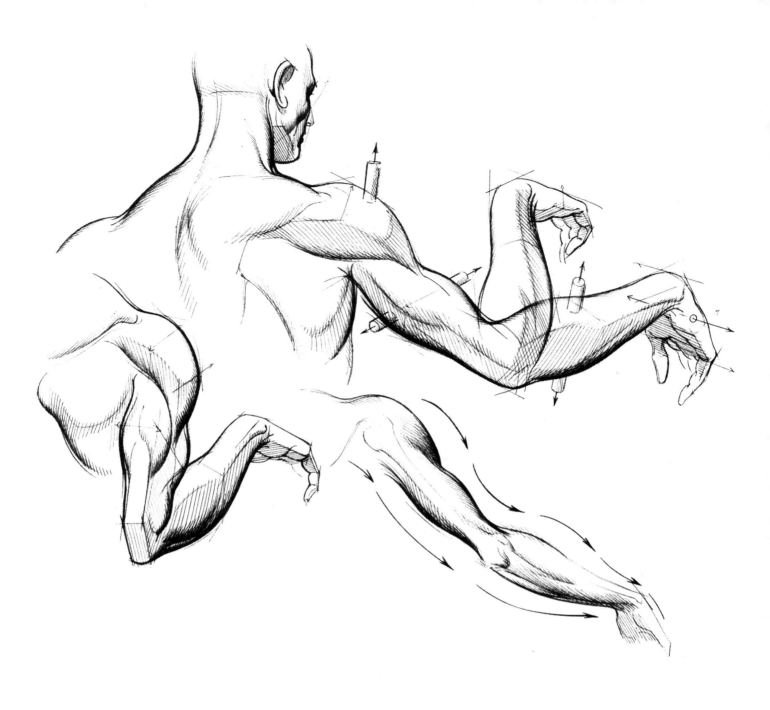

UPPER AND LOWER ARM

The main masses of the upper and lower arm are good
examples of the principle of *contraposition*—one form
being in opposition to, or moving in a different direction
from, another. For example, the shoulder mass thrusts up-
ward, while the direction of the biceps and triceps is
frontward and backward; the forearm repeats the up-and-
down direction of the shoulder and is opposed by the hori-
zontal angle of the hand. The upper sketch shows the re-
tracted and extended arm positions, while the lower left
sketch emphasizes form planes. Observe how the con-
traposed masses shown in the lower right sketch produce
an undulant, wavelike rhythm of crests and troughs along
the entire length of the extended arm.

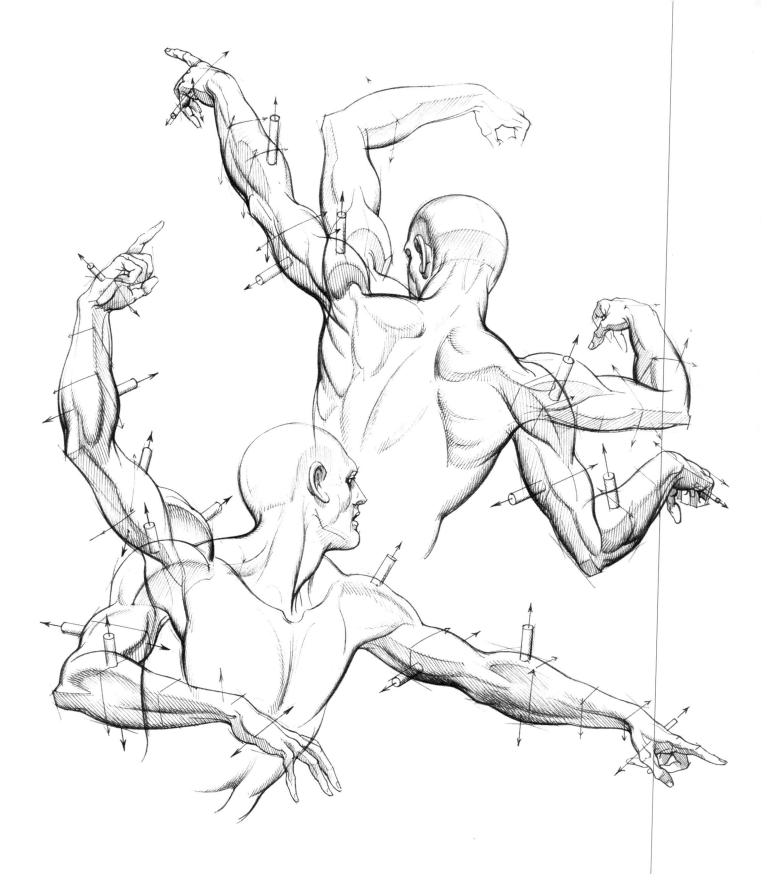

CONTRAPOSED MASSES

These drawings also show the undulant rhythms produced by contraposed masses (direction indicated by arrows). In this sequence of varied movements of the upper and lower arm, note the tendency of the forearm to lift at the upper wrist. The palm takes a decided slope downward, depending on the natural flexion of the hand.

UNDERARM CURVES

When the arm is brought up and extended forward, it curves *under* from armpit to elbow and from elbow to wrist. This never varies, no matter what position the entire arm may take. Note the reversed backward direction of the arm in the drawing at right. Even with the elbow raised, the double underarm curve is still present. At the end of the lower arm curve, the palm interrupts this movement with a decisive change of direction.

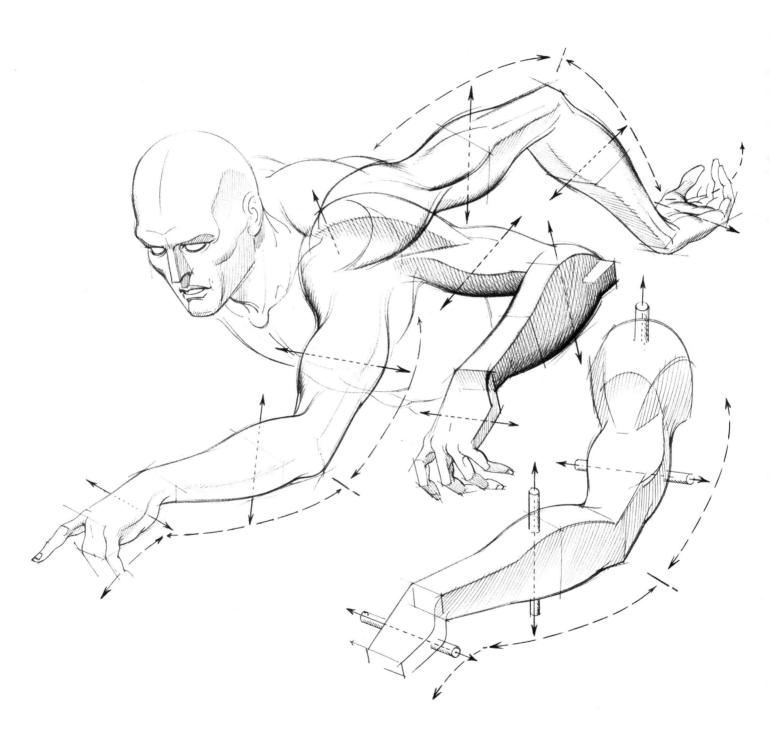

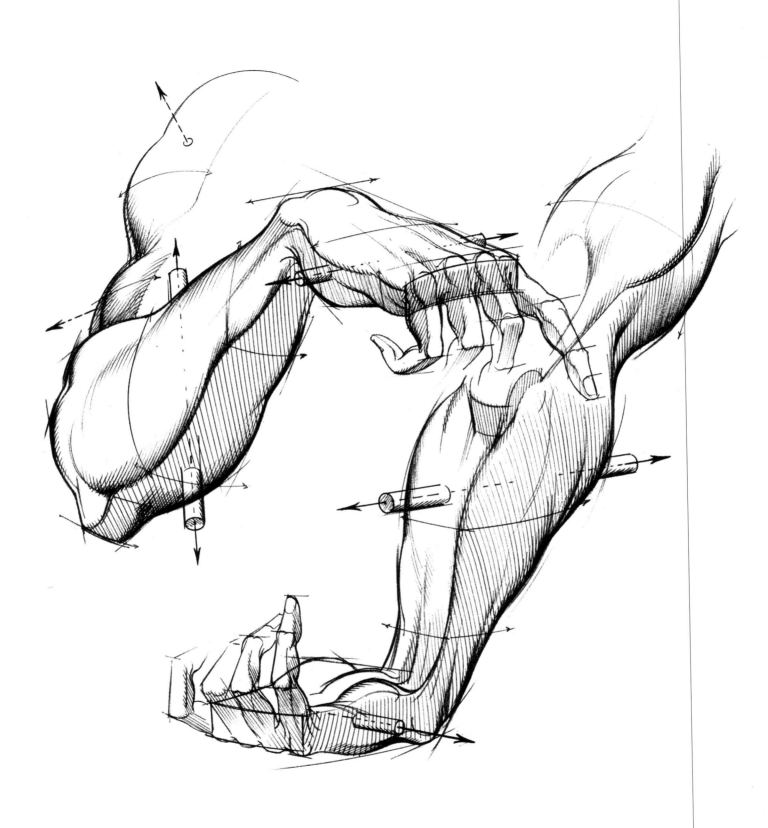

PALM WEDGE

The wrist *flattens* at the end of the forearm, and the palm
thrusts out like a spatulate wedge, thick at the center and
narrower at the front where the finger knuckles emerge. This
palm wedge is the governing form of all the secondary hand
structures.

WRIST AND PALM CONNECTION

In this rear view of the flexed forearm and hand, the palm wedge is seen from its top *(dorsal)* side. The tapered, flat wrist is joined to the spread palm, and these two forms remain consistent in any rotational direction the arm may take. Note that the flexed arm with forearm upraised and drawn inward permits the thumb to contact the shoulder *(deltoid)* muscle about midpoint on its upper bulge. Should the upper arm be raised vertically, the thumb would reach into the deep pit of the deltoid.

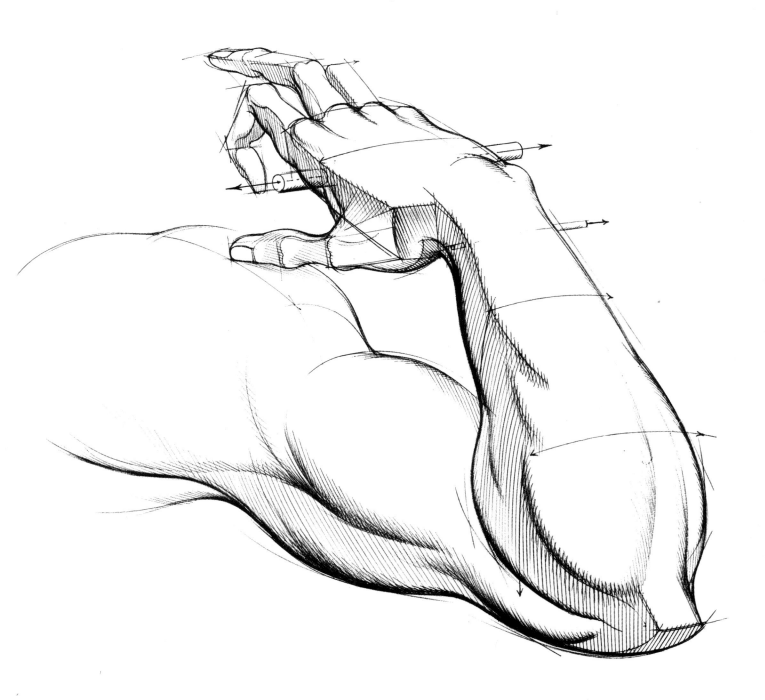

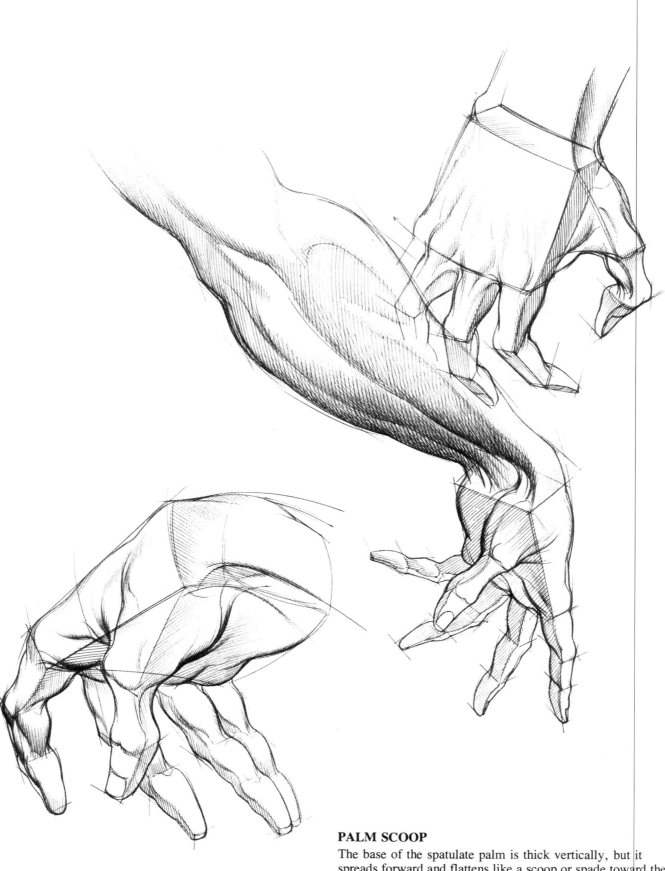

PALM SCOOP

The base of the spatulate palm is thick vertically, but it spreads forward and flattens like a scoop or spade toward the front. The palmar side of the hand is hollow and dome-shaped; the dorsal side is somewhat rounded also, but much less so than the palm side.

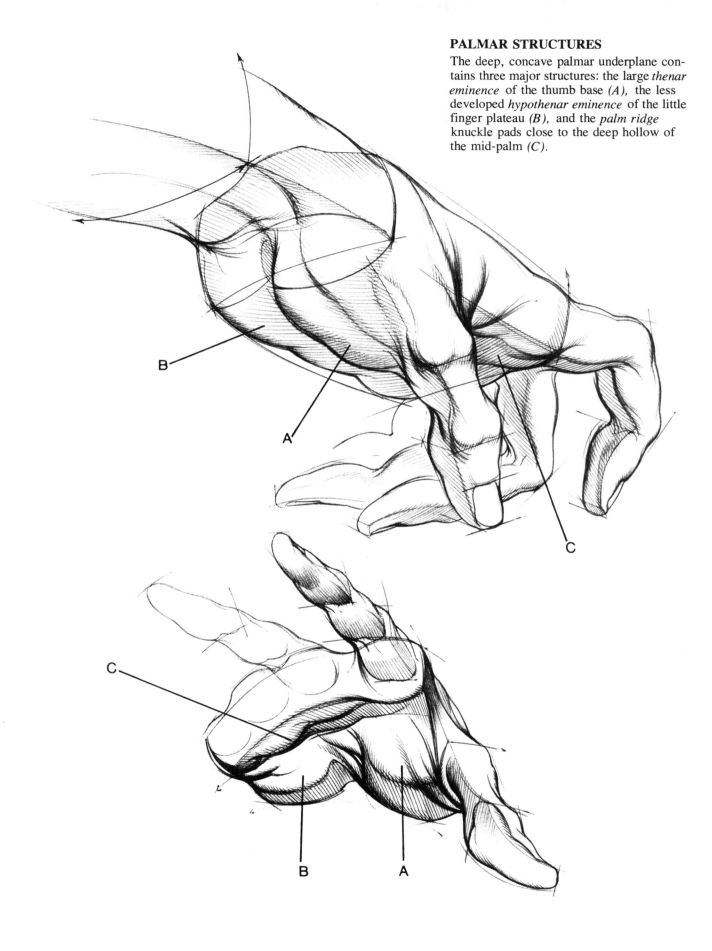

PALMAR STRUCTURES

The deep, concave palmar underplane contains three major structures: the large *thenar eminence* of the thumb base *(A)*, the less developed *hypothenar eminence* of the little finger plateau *(B)*, and the *palm ridge* knuckle pads close to the deep hollow of the mid-palm *(C)*.

17

PALM WEDGE TRIANGLE

Three different views of the palm wedge also show the major understructures: the ball of the thumb (thenar eminence), the heel of the palm on the little finger side (hypothenar eminence), and the palm ridge knuckle pads. Note how the forms resemble a triangle with its apex pointing upward toward the shaft of the arm.

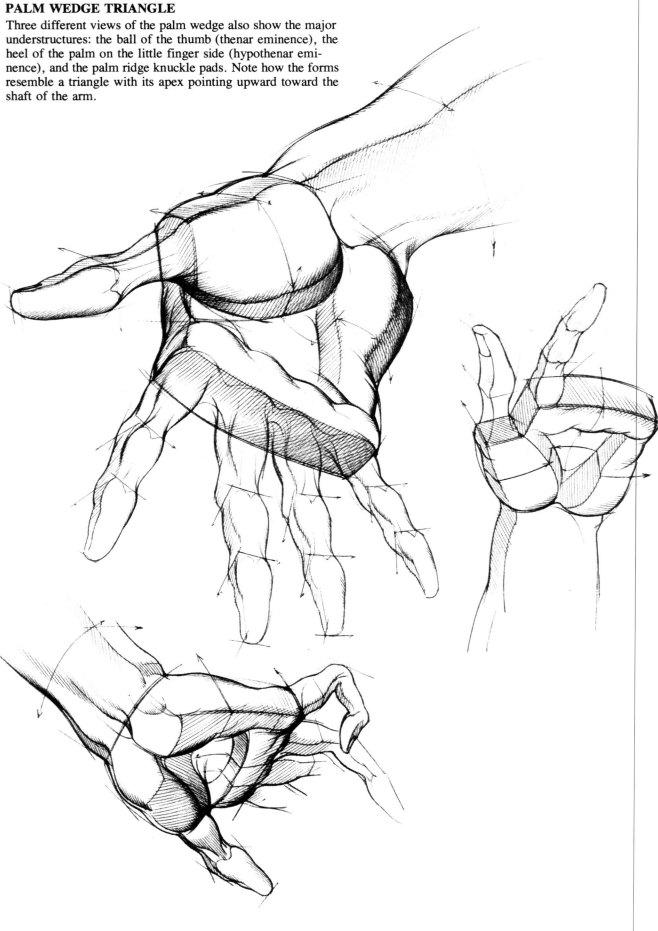

THUMB TRIANGLE
The thumb emerges from the palm wedge as a narrow triangular block supported from underneath by the fleshy, curved thenar eminence.

PALM CURVATURE

Two types of curves make up the palm wedge. The dorsal view of the hand at left shows the *latitudinal* arcs formed by the wrist, the palm knuckles, and the bones of the fingers. These form a sequence of ellipses, beginning at the point where the wrist joins the lower arm and continuing to the fingers. The cross section of the thick rear palm at right shows the concave palm and the *longitudinal* curves running lengthwise from wrist to fingers.

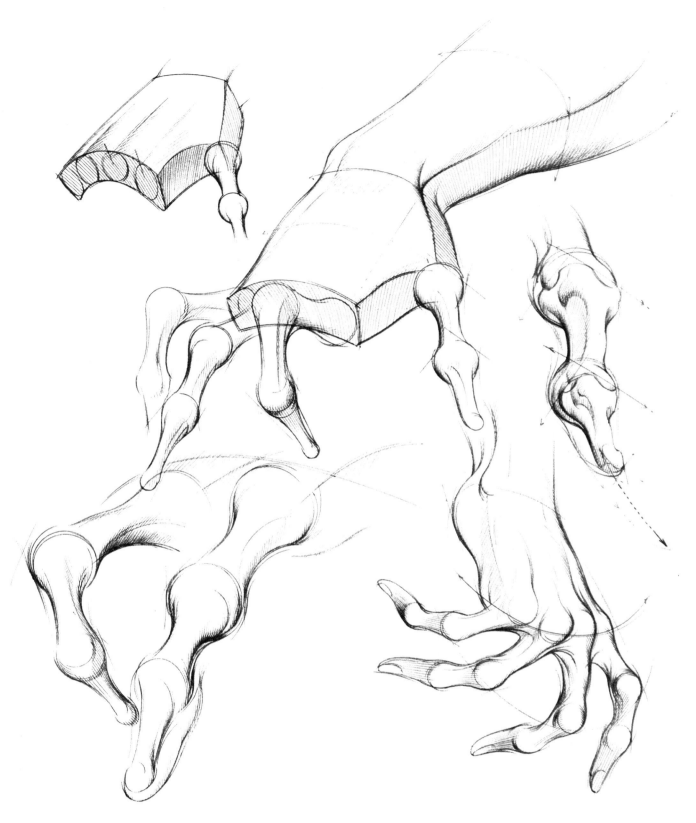

ROD AND BALL FORMS

As the fingers emerge from the palm knuckles, they develop three-part rod and ball forms—finger shank and knuckle capsule—as shown in the enlarged detail at center right. The rod and ball device is an easy and effective method for sketching direct hand action. Finger movements can be developed from a tentative exploration to an integrated drawing. The sketches at bottom are examples of beginning explorations before arriving at a final drawing.

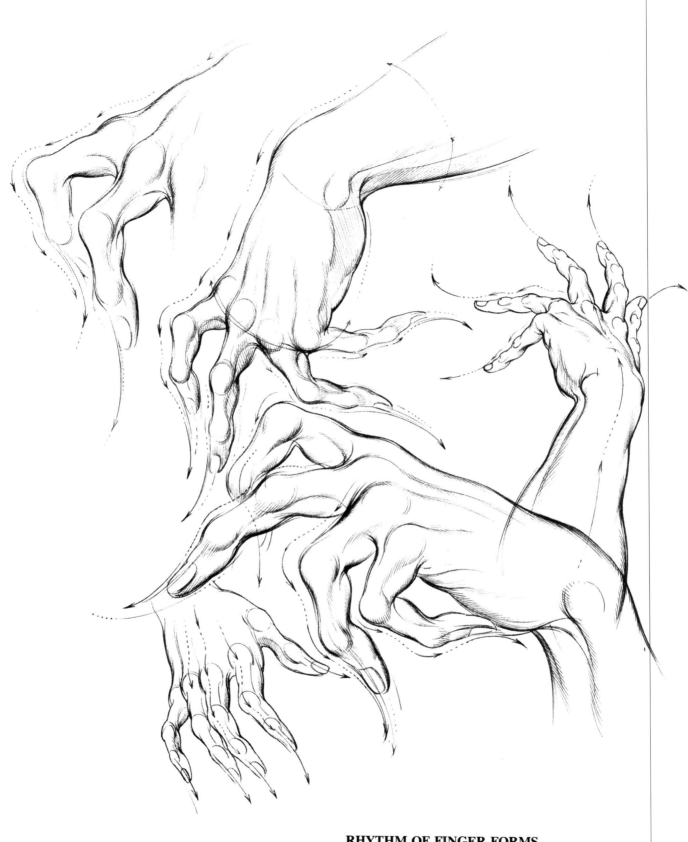

RHYTHM OF FINGER FORMS

When the rod and ball forms are integrated, they exhibit the same type of crest and trough rhythm as noted earlier in the drawings of the contraposed arm masses. A decisive upswing occurs at the fingertips in a variety of elevated curves, depending on finger movement and hand position.

SYMMETRY OF FORMS

The hand is seen from a top and underside view here, and the arrows trace out the symmetry of expanding (knuckles) and compressing (finger shanks) forms. This symmetry, however, would not be apparent from side views.

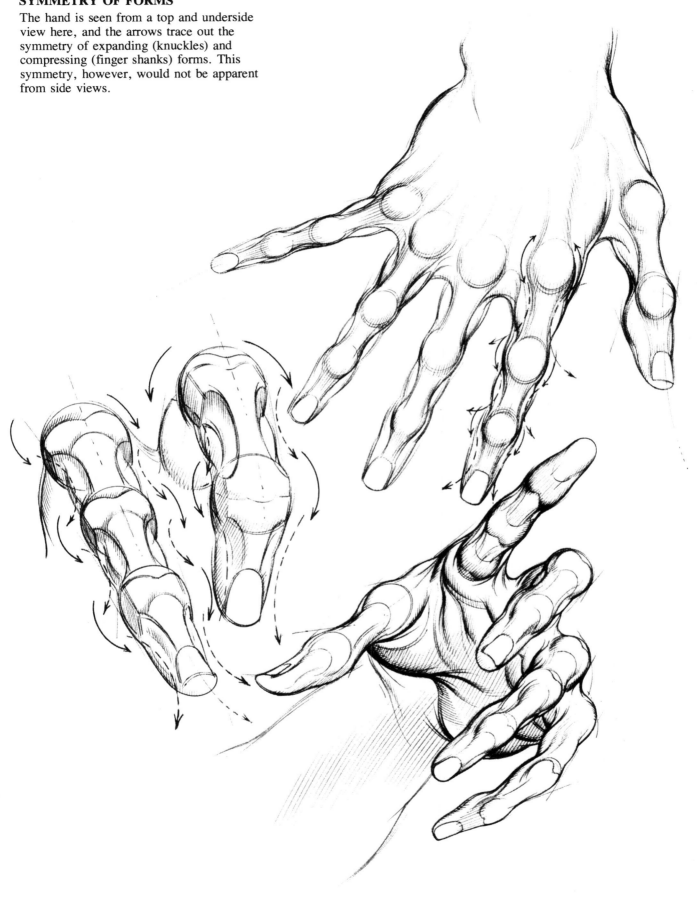

2.
PROPORTIONS AND MEASUREMENTS

Anyone who has tried to draw the human figure has quickly learned that the hand is among the most complex of the body forms. To draw the hand accurately and with precision, you must know how to relate the individual parts to each other and how to unify the separate elements. A knowledge of proportions is necessary in art and should be used as a learning stage to new expressive adventures. This chapter will introduce essential measuring cues and their use in drawing the hand in correct proportion. Once the interrelated measurements are understood, you can create dynamic and alive hands without needing a model. You will also see the underlying symmetry and unity of the structures of the hand.

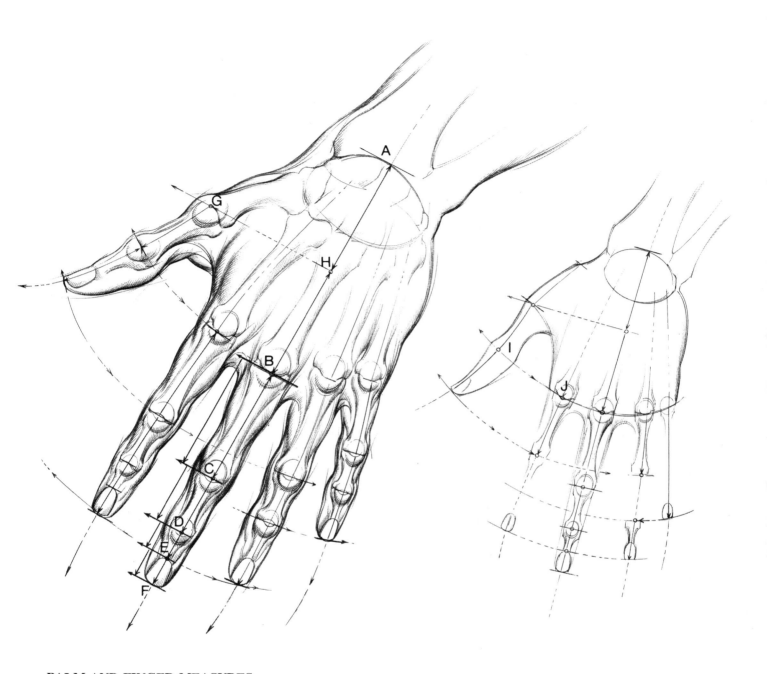

PALM AND FINGER MEASURES

The palm is the governing form of the hand, and it varies in shape from rectangular to square. From it, proportions and measurements of the entire hand can be determined. Note two important measuring cues shown here. First, the palm begins at the center of the wrist *(A)* and extends to the base of the middle finger *(B)*, which forms part of the palm knuckle bulge. Second, the thumb emerges from the palm as a narrow triangular wedge extending at about a 25- to 30-degree angle. The base of the triangle *(G)* aligns with the vertical midpoint of the palm *(H)*.

The palm at its longest point *(A to B)* is the same length as the middle finger *(B to F)*. Every section of the middle finger is half the length of the one above it. Thus the first phalanx and finger knuckle *(B to C)* is half the length of the entire finger; the middle phalanx and second knuckle *(D to F)* is

half the length of the first phalanx; and if the terminal phalanx *(D to F)* is divided, we have the length of the fingernail *(E to F)*.

Other symmetries also exist. The schematic drawing at right shows the index and fourth fingers to be equal in length. Check this in both drawings and on your own hand. Also, the tips of the index and fourth fingers terminate at the nail bed of the middle finger. Not all people show these equal lengths exactly, but a large enough majority have them to make this a feasible premise. Now note how the end of the little finger aligns with the knuckle of the terminal phalanx of the fourth finger. The thumb also aligns with the palm and palm knuckles—the index finger knuckle *(I)* lines up with the knuckle at the midpoint of the thumb *(J)*, and the tip of the thumb lines up with the first phalanx of the index finger.

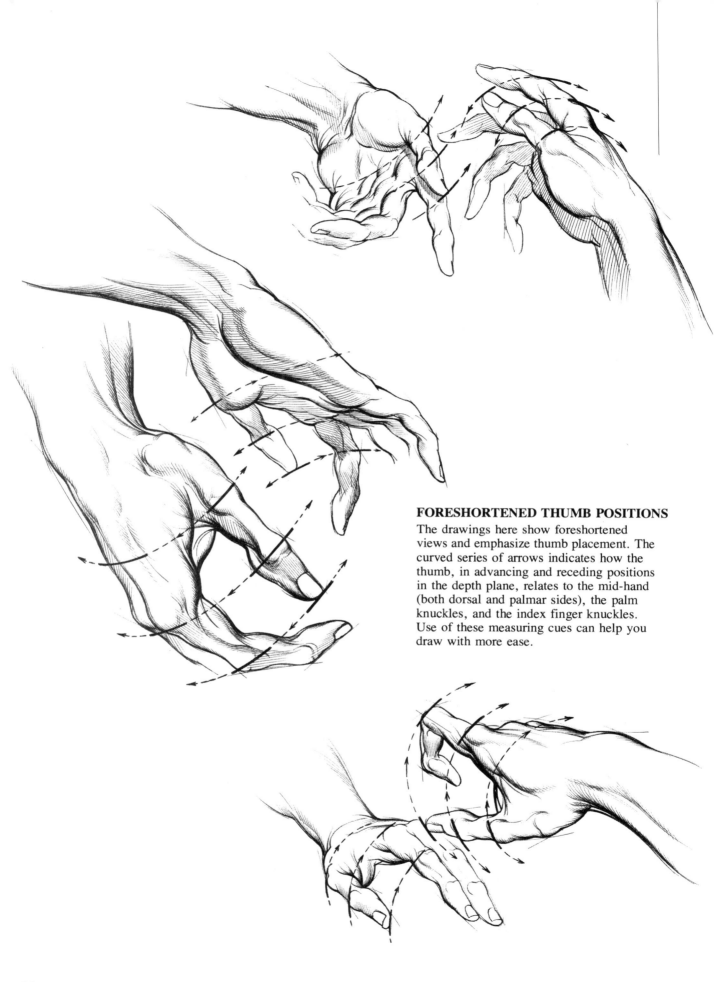

FORESHORTENED THUMB POSITIONS

The drawings here show foreshortened
views and emphasize thumb placement. The
curved series of arrows indicates how the
thumb, in advancing and receding positions
in the depth plane, relates to the mid-hand
(both dorsal and palmar sides), the palm
knuckles, and the index finger knuckles.
Use of these measuring cues can help you
draw with more ease.

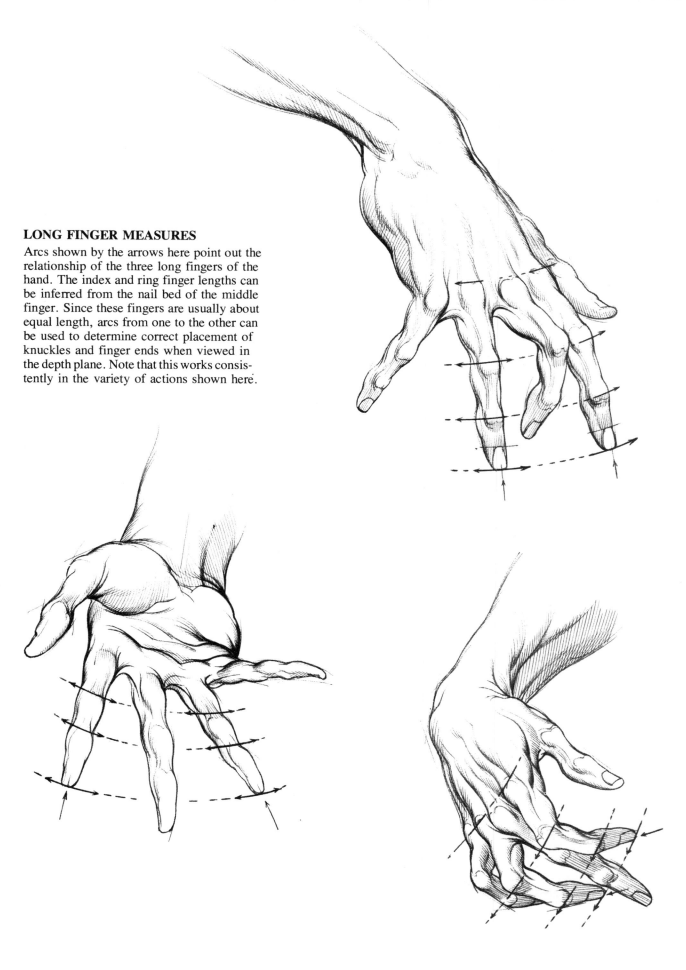

LONG FINGER MEASURES

Arcs shown by the arrows here point out the relationship of the three long fingers of the hand. The index and ring finger lengths can be inferred from the nail bed of the middle finger. Since these fingers are usually about equal length, arcs from one to the other can be used to determine correct placement of knuckles and finger ends when viewed in the depth plane. Note that this works consistently in the variety of actions shown here.

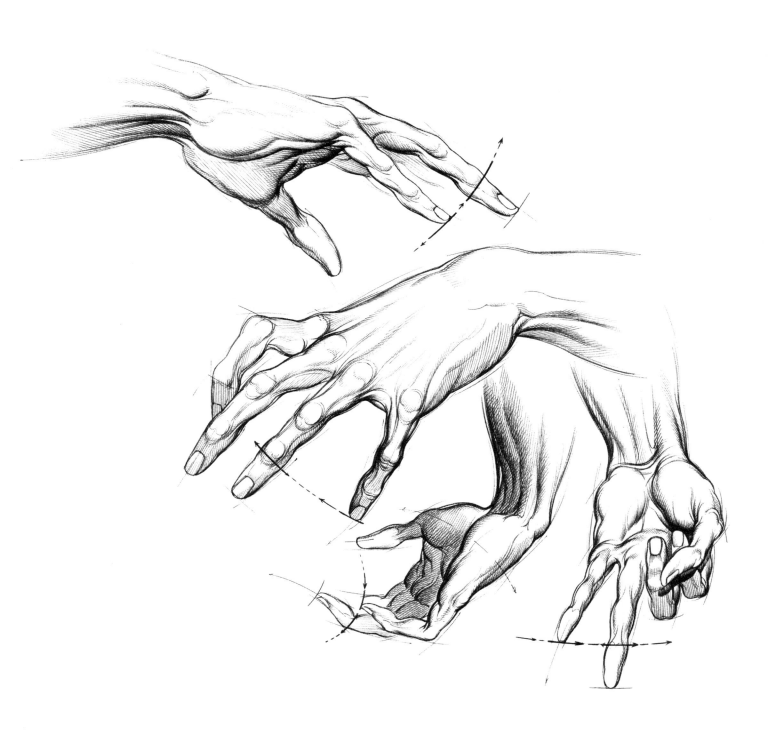

LITTLE FINGER MEASUREMENTS

The tip of the little finger lines up with the last knuckle of the ring finger; thus finger placement can be easily integrated in all positions when this measuring cue is used. Correct positions of other fingers are based on measuring cues already described in previous drawings. For example, observe the alignment of thumb knuckle with mid-palm in the drawing at extreme right.

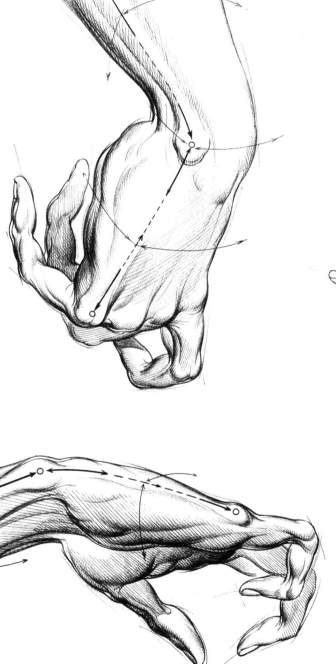

ANGLE OF ULNA AND LITTLE FINGER KNUCKLE

The large palm knuckle on the dorsal side of the hand, from which the little finger emerges, is directly in line with the ulnar protrusion, the base of the outer bone of the arm protruding at the wrist. This important relationship marks a transition point between top and side planes of the *outside* of both hand and arm. This alignment is quite apparent in the side view shown at lower left, but correct placement of these points is less obvious, though essential, when the hand is drawn from angles, as shown in the drawings at upper left and below.

INSIDE PLANES OF HAND AND ARM

The top sketch shows the line marking the side edge of the index finger knuckles and on up the arm. This line defines the transition point between top and side planes of the *inside* of the hand and arm. It rises high at the wrist and palm and then courses down to the fingertips. The juncture with the wrist (zero point between arrow flows) occurs at the end of the inner forearm bone, the *styloid process* of the *radius*. The line of the thumb rises at an angle to meet the line of the index finger at the wrist girdling line. The juncture at the styloid process is invariable. The two lower sketches show how this point of intersection is consistent even in different hand positions and different views.

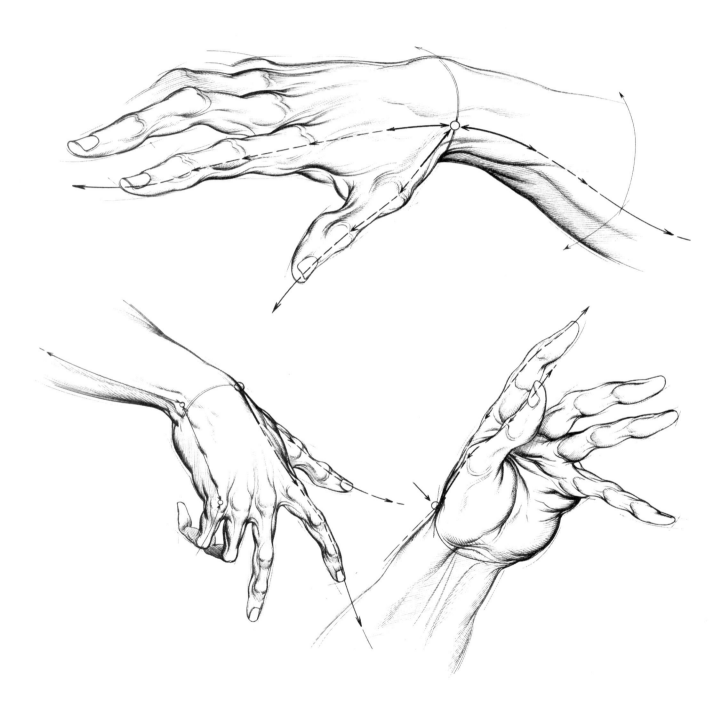

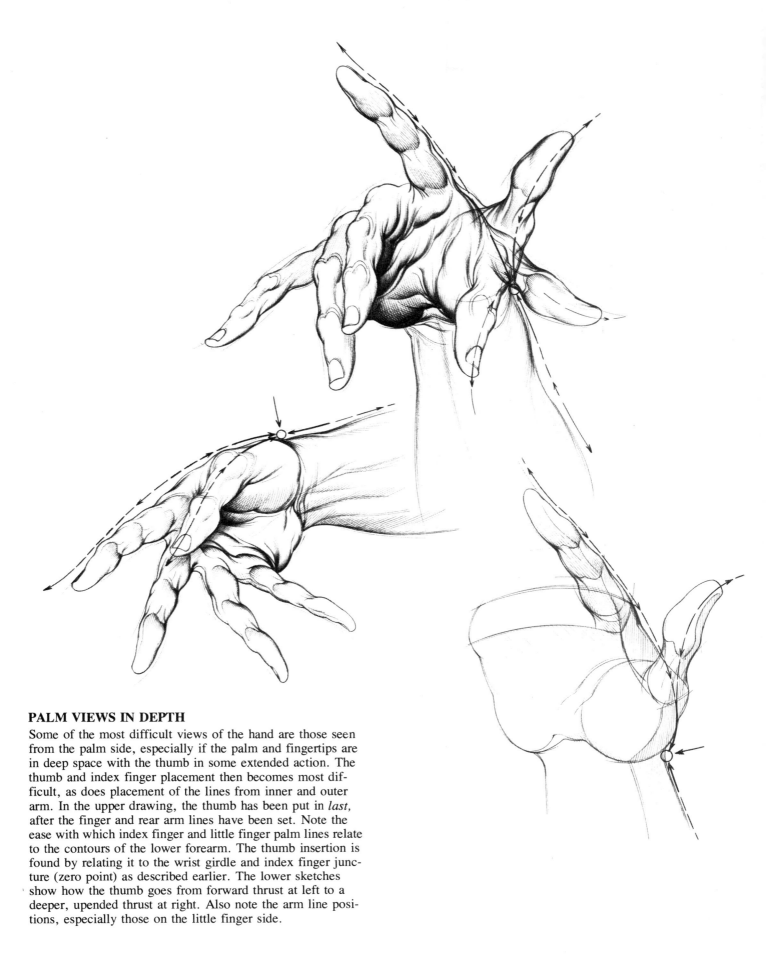

PALM VIEWS IN DEPTH

Some of the most difficult views of the hand are those seen
from the palm side, especially if the palm and fingertips are
in deep space with the thumb in some extended action. The
thumb and index finger placement then becomes most dif-
ficult, as does placement of the lines from inner and outer
arm. In the upper drawing, the thumb has been put in *last,*
after the finger and rear arm lines have been set. Note the
ease with which index finger and little finger palm lines relate
to the contours of the lower forearm. The thumb insertion is
found by relating it to the wrist girdle and index finger junc-
ture (zero point) as described earlier. The lower sketches
show how the thumb goes from forward thrust at left to a
deeper, upended thrust at right. Also note the arm line posi-
tions, especially those on the little finger side.

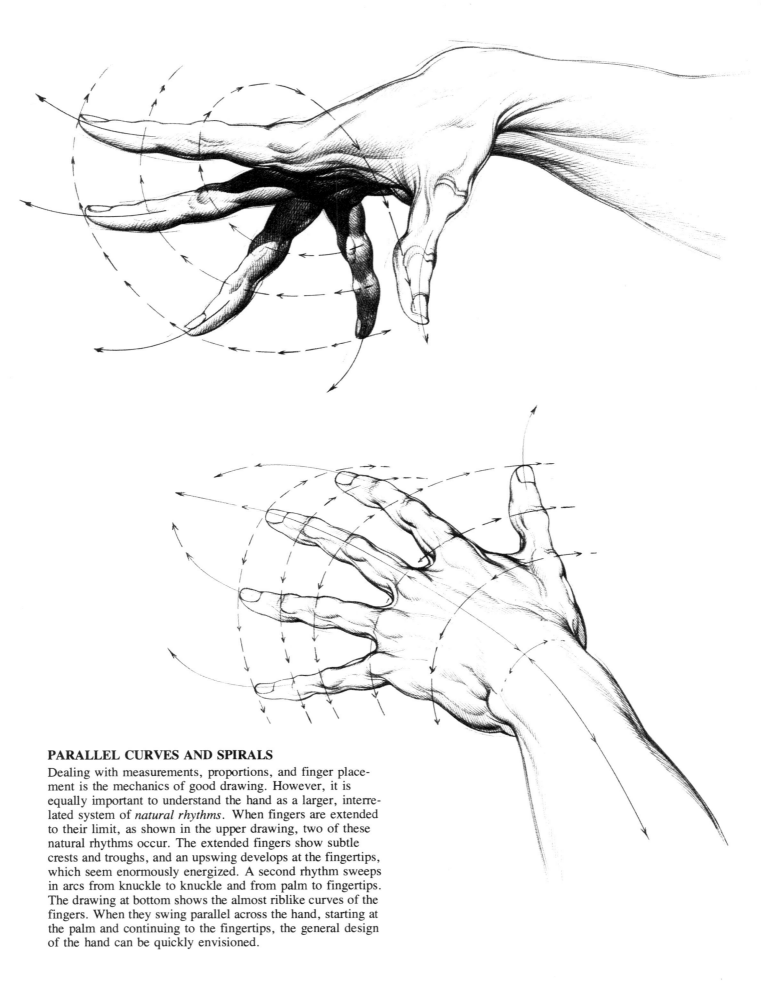

PARALLEL CURVES AND SPIRALS

Dealing with measurements, proportions, and finger place-
ment is the mechanics of good drawing. However, it is
equally important to understand the hand as a larger, interre-
lated system of *natural rhythms*. When fingers are extended
to their limit, as shown in the upper drawing, two of these
natural rhythms occur. The extended fingers show subtle
crests and troughs, and an upswing develops at the fingertips,
which seem enormously energized. A second rhythm sweeps
in arcs from knuckle to knuckle and from palm to fingertips.
The drawing at bottom shows the almost riblike curves of the
fingers. When they swing parallel across the hand, starting at
the palm and continuing to the fingertips, the general design
of the hand can be quickly envisioned.

32

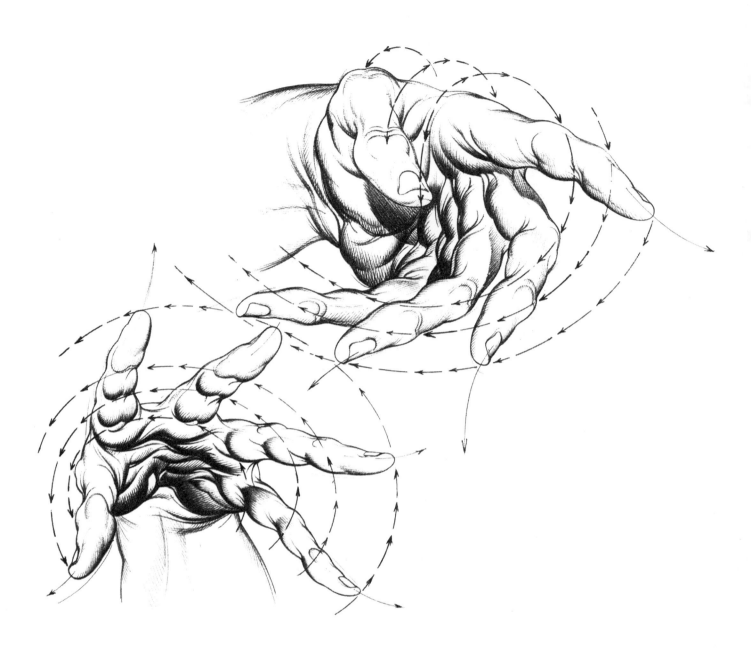

SPIRAL AND ARC RHYTHMS

Awareness of the elliptical spirals of the hand may produce
spontaneous insight into form and can help you organize form
when the hand is seen deeply foreshortened or with projected
or closing fingers, as in the two drawings here. Note how
vitalized the fingers look here. It doesn't matter at what point
you start to lay in the natural rhythms, beginning with a free
sketch first or with knuckle positioning, the sense of this
rhythm will help you greatly in your sense of the design.

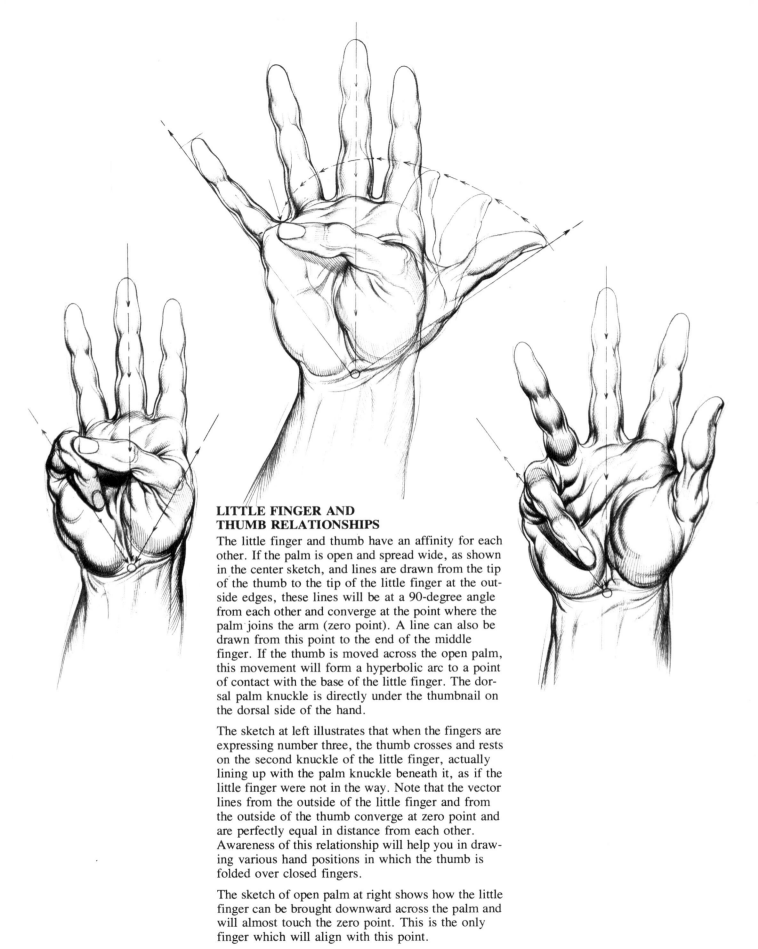

LITTLE FINGER AND THUMB RELATIONSHIPS

The little finger and thumb have an affinity for each other. If the palm is open and spread wide, as shown in the center sketch, and lines are drawn from the tip of the thumb to the tip of the little finger at the outside edges, these lines will be at a 90-degree angle from each other and converge at the point where the palm joins the arm (zero point). A line can also be drawn from this point to the end of the middle finger. If the thumb is moved across the open palm, this movement will form a hyperbolic arc to a point of contact with the base of the little finger. The dorsal palm knuckle is directly under the thumbnail on the dorsal side of the hand.

The sketch at left illustrates that when the fingers are expressing number three, the thumb crosses and rests on the second knuckle of the little finger, actually lining up with the palm knuckle beneath it, as if the little finger were not in the way. Note that the vector lines from the outside of the little finger and from the outside of the thumb converge at zero point and are perfectly equal in distance from each other. Awareness of this relationship will help you in drawing various hand positions in which the thumb is folded over closed fingers.

The sketch of open palm at right shows how the little finger can be brought downward across the palm and will almost touch the zero point. This is the only finger which will align with this point.

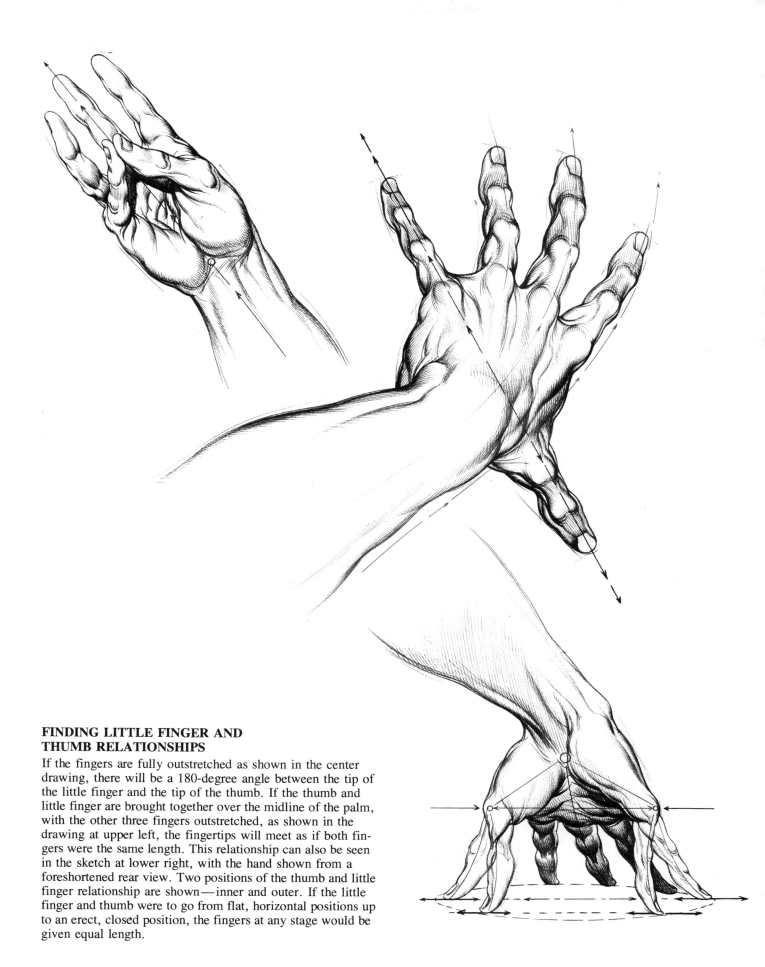

FINDING LITTLE FINGER AND THUMB RELATIONSHIPS

If the fingers are fully outstretched as shown in the center drawing, there will be a 180-degree angle between the tip of the little finger and the tip of the thumb. If the thumb and little finger are brought together over the midline of the palm, with the other three fingers outstretched, as shown in the drawing at upper left, the fingertips will meet as if both fingers were the same length. This relationship can also be seen in the sketch at lower right, with the hand shown from a foreshortened rear view. Two positions of the thumb and little finger relationship are shown—inner and outer. If the little finger and thumb were to go from flat, horizontal positions up to an erect, closed position, the fingers at any stage would be given equal length.

FINGERS IN STRESS POSITIONS

In the upper, deep palmar view, with fingers stressed in full extension, note how the little finger and thumb appear to be tips of symmetrical horns, lying at the end of a great wavelike arc (see smaller schematic at left). The lower sketch shows fingers more outstretched, with thumb and little finger moving toward each other but still maintaining the wavelike form.

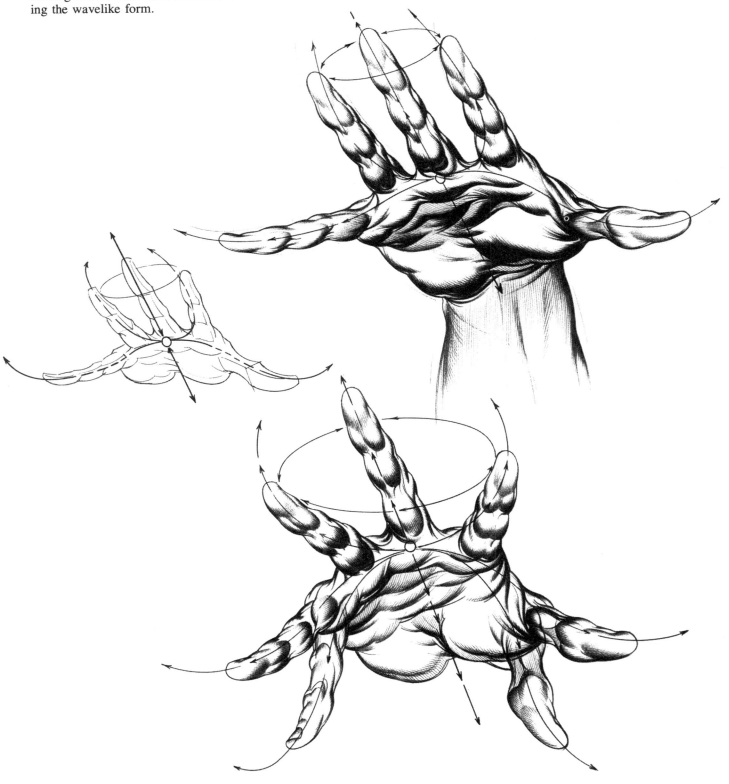

SPECIAL CHARACTERISTICS

All hands and arms have a special behavioral characteristic which they also share with the legs—they tend to curve inward. This may account for the consistent undercurve of the arms mentioned earlier in Chapter 1. As the arms move forward in action, the tension projects the hands *outward* from the lines of the arms, as shown in the drawing above. Note especially the directional arrows on the forearms and the splayed index finger thrusts.

Note in the drawing below that fingernails of receding fingers *rotate* from an almost straight-on view, shown by the index finger, to a curve on the little finger that is almost out of sight. The thumbnail, however, rotates according to the action of the hand or the action of the thumb.

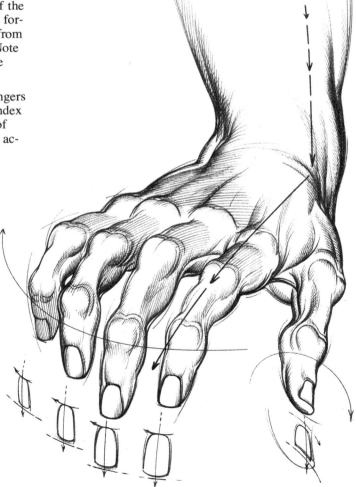

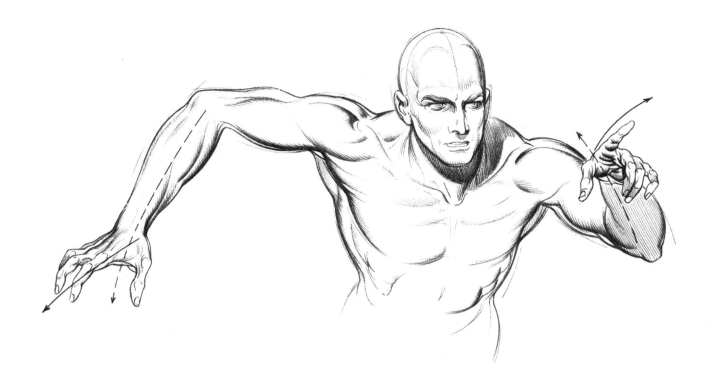

SPECIAL CHARACTERISTICS

All hands and arms have a special behavioral characteristic which they also share with the legs—they tend to curve inward. This may account for the consistent undercurve of the arms mentioned earlier in Chapter 1. As the arms move forward in action, the tension projects the hands *outward* from the lines of the arms, as shown in the drawing above. Note especially the directional arrows on the forearms and the splayed index finger thrusts.

Note in the drawing below that fingernails of receding fingers *rotate* from an almost straight-on view, shown by the index finger, to a curve on the little finger that is almost out of sight. The thumbnail, however, rotates according to the action of the hand or the action of the thumb.

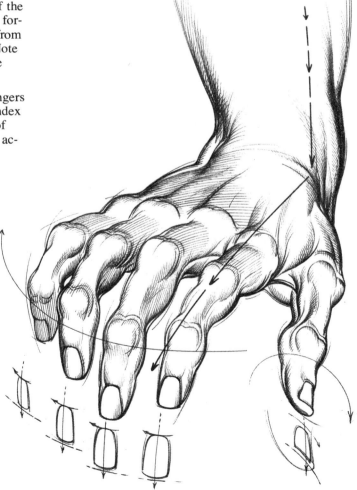

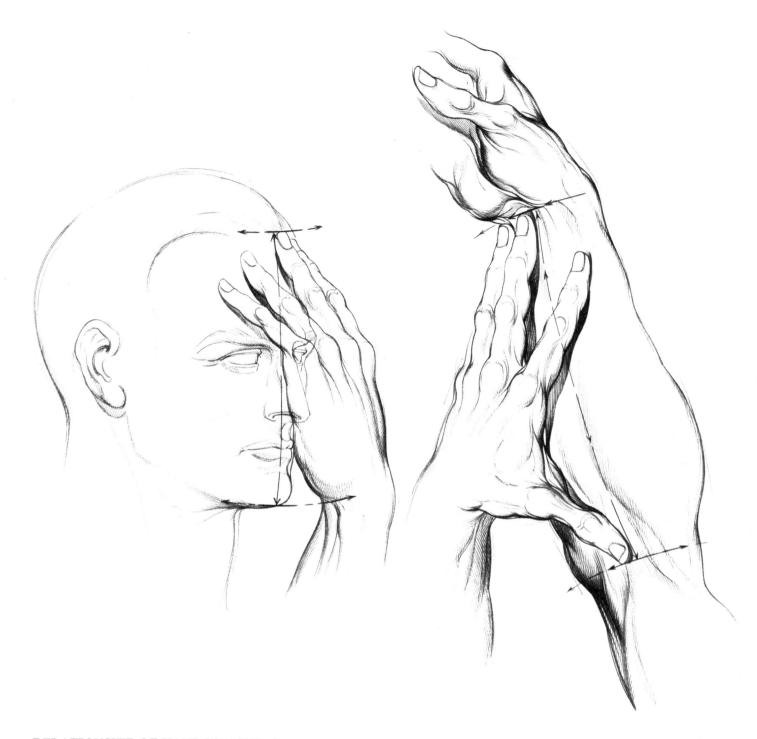

RELATIONSHIP OF HAND MEASURES
TO FACE AND ARM

If the base of the palm is level with the chin base, as shown
at left, the fingers will reach the brow, and the long middle
finger will touch the hairline. If the thumb is placed in the
inner arm elbow depression, as shown at right, the hand will
span from that point to the base of the palm. A knowledge of
these proportions will be extremely useful when dealing with
the figure as a whole.

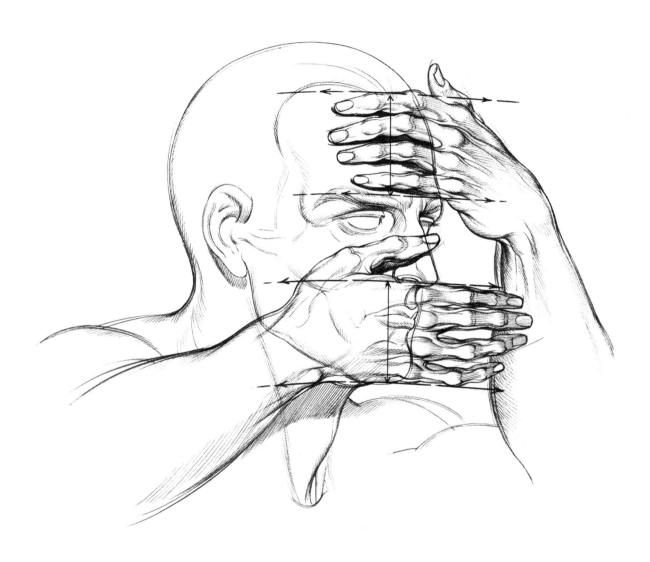

HAND AND FACE MEASUREMENTS

In a final note on measured relationships, if the hand is
placed in side position and laid on the brow, it will fit almost
exactly between the hairline and the eyebrows. In some
cases, a large hand will also cover the nose root. The palm
can also be placed in side position in contact with the nose
base, and the side of the palm will reach the base of the chin.
These measuring cues can be especially useful when drawing
multiple figure compositions.

3.
ANATOMY AND STRUCTURE

When the artist studies human anatomy, he is not usually pursuing the same goals as the medical doctor or the scientist. He is searching for visual form which can be translated aesthetically and augmented imaginatively. However, knowledge of anatomy is essential for an understanding of various attitudes, postures, and movements. It allows the artist to truly understand the surface contours of the body because he knows the forms and structures underneath. It also teaches him why the surface forms appear as they do. Hopefully you will not be so caught in the study of the parts that you forget the rhythmic and unified whole. As you go through this chapter, you'll see the efficiency, order, and symmetry of the forms of the hand and the integrated way in which all work together to give the hand its wide variety of movement and response.

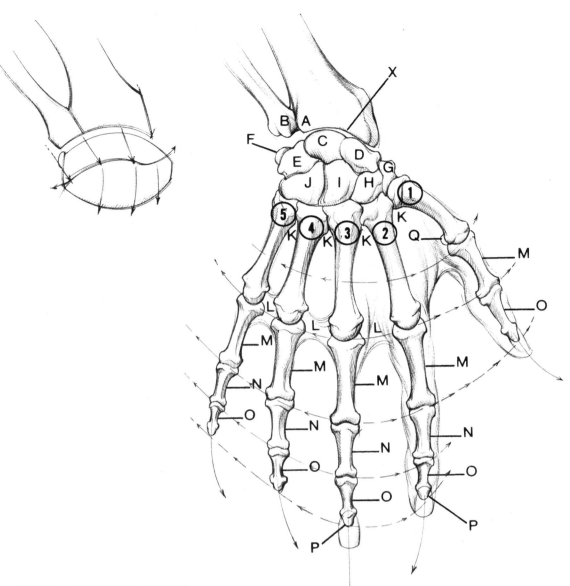

WRIST AND HAND BONES

The dorsal side of the hand, including the wrist, has a particularly bony surface, with many protrusions lying just under the skin. The hand begins above the wrist at the point where the *radius (A)* and *ulna (B)* form the pivotal *radio-ulnar joint.* Note that only the radius articulates with the three top wrist bones (*carpal* bones) to form the *radio-carpal joint (X).*

Below the radio-carpal joint, the eight compact wrist bones as a unit make up the *carpus,* formed in a close-set ellipse, as seen in the schematic at right. Individually, they are known as *carpals,* and each has a separate name. The central *lunate* bone *(C)* tends to elevate the upper tier composed of the *scaphoid* bone *(D),* a boat-shaped form on the inside; the moon-shaped *lunate* bone; the wedge-shaped *triquetrum* bone on the outside *(E)*; and the pea-shaped *pisiform* bone *(F).* Four larger carpals make up the lower tier. Articulating directly with the thumb is the saddle-shaped *trapezium* bone *(G)*; contacting the index finger is the boot-shaped *trapezoid* bone *(H)*; next, the keystone-shaped *capitate* bone *(I)*; outside, the hooked *hamate* bone *(J).*

Attached to the carpals are the *metacarpals* (collectively called the *metacarpus*). These bones of the palm have no individual names but are simply identified by number. The thumb is the *first metacarpal,* the index finger, the *second metacarpal,* and so on. They have characteristics of long bones, with a shaft and two ends, the upper end articulating with the carpals and the lower end attaching to the *phalanges* or finger bones. The carpals and metacarpals form the palm and are greatly limited in movement, since they are bound closely at their bases by the *metacarpal ligaments (K)* and at their heads by the *intermetacarpal ligaments (L).* The exception to this is the *first metacarpal* of the thumb. It is attached to the trapezium by a capsular ligament only, which allows it much wider activity than the other four.

Attached to the metacarpal bones are the *phalanges,* or fingers, of the hand. Each finger is called a *phalanx,* and each phalanx has three units—the *proximal phalanx (M),* the *medial phalanx (N),* and the *terminal phalanx (O).* The thumb again is the exception, having no medial phalanx. The terminal phalanx has a horny, shell-like substance emerging from it called the *unguis (P)* or fingernail. Two tiny bones scarcely worth mentioning, almost blended with the ligaments and surface tissue, are the *sesamoid* bones *(Q)* lying on the lower inside surface of the first metacarpal of the thumb.

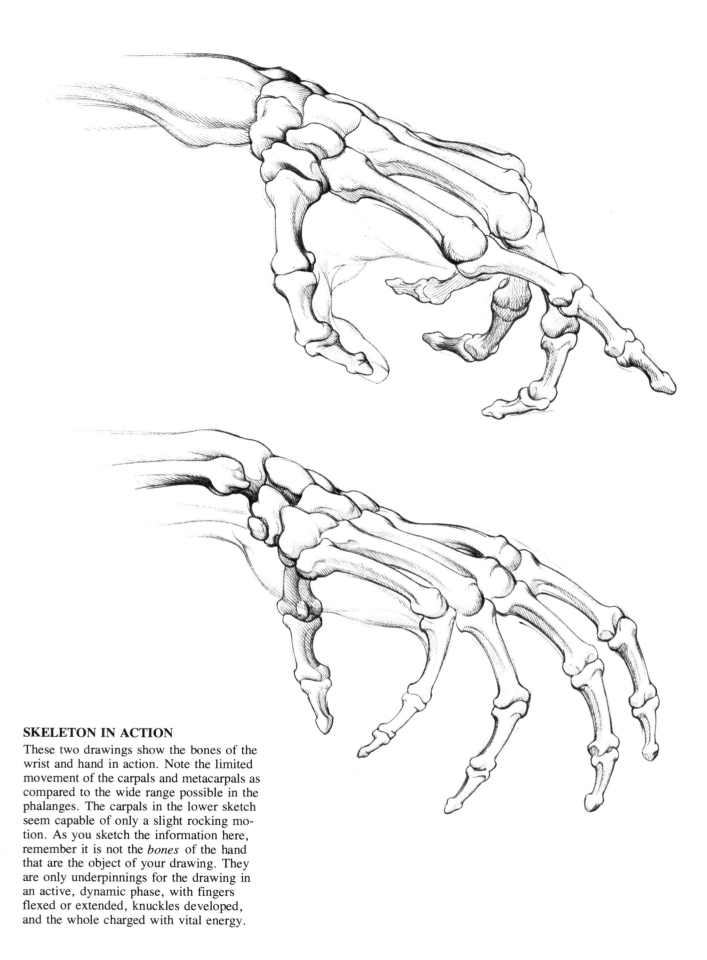

SKELETON IN ACTION

These two drawings show the bones of the wrist and hand in action. Note the limited movement of the carpals and metacarpals as compared to the wide range possible in the phalanges. The carpals in the lower sketch seem capable of only a slight rocking motion. As you sketch the information here, remember it is not the *bones* of the hand that are the object of your drawing. They are only underpinnings for the drawing in an active, dynamic phase, with fingers flexed or extended, knuckles developed, and the whole charged with vital energy.

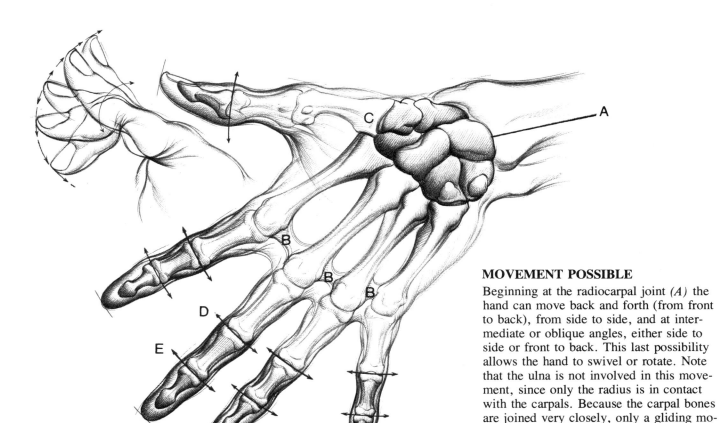

A

C

B

B

B

D

E

MOVEMENT POSSIBLE

Beginning at the radiocarpal joint *(A)* the hand can move back and forth (from front to back), from side to side, and at intermediate or oblique angles, either side to side or front to back. This last possibility allows the hand to swivel or rotate. Note that the ulna is not involved in this movement, since only the radius is in contact with the carpals. Because the carpal bones are joined very closely, only a gliding motion can occur; however, as noted in the previous drawing, a slight rocking forward and backward is possible because of the curve of the two tiers.

The large hand shown here is drawn with light and dark areas. The wrist bones and the finger bones from the second joint down are *accented,* as are the base joints of the four metacarpal (palm) bones. *All other areas are kept light.* The darker areas show the forms and joints which perform a limited movement; the lighter areas delineate forms which have freer movement.

The four long metacarpal bones attached to both wrist bones and intermetacarpals are so constrained by the intermetacarpal ligaments *(B)* that movement between them is negligible. The exception is the high thumb joint at the trapezium wrist bone *(C),* which is capable of much more freedom since no ligament controls it. The interphalangeal joints *(D, E)* on the middle and terminal forms of the fingers, darkened with transverse arrows on the full-hand drawing, are capable of only forward and backward movement.

Note in the action sketch of the thumb at upper left that the characteristic movement of the distal phalanx of the thumb is toward and away from the palm. This movement is the same for all phalanges of the other four fingers, as shown in the action drawing below. From the middle to the end joints, they can perform *only* a hinge movement.

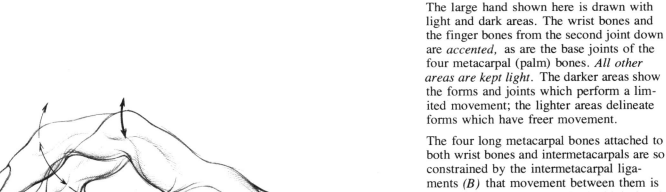

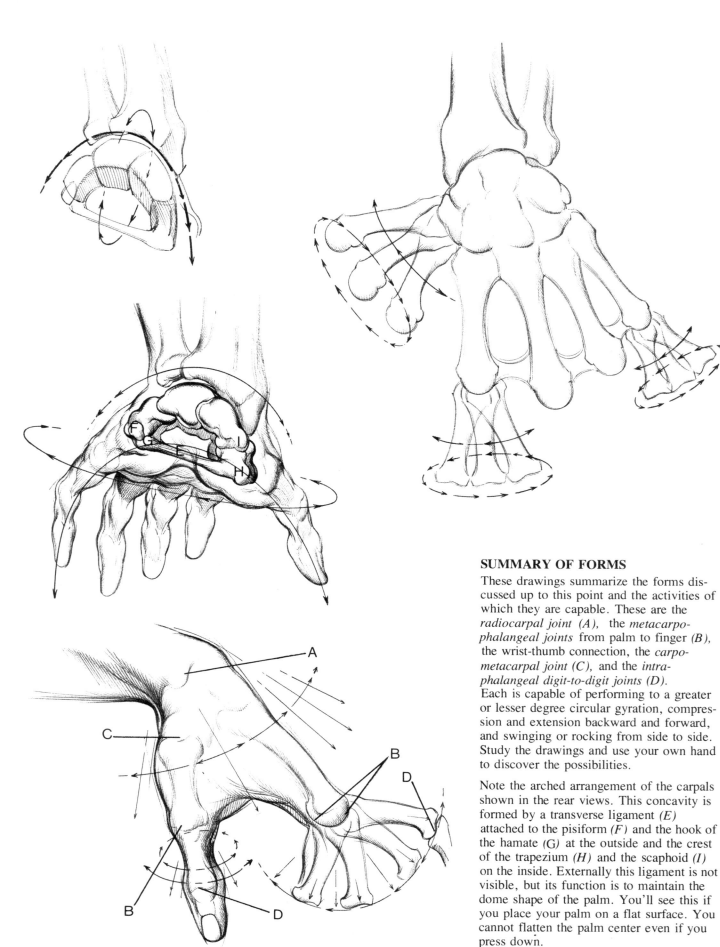

SUMMARY OF FORMS

These drawings summarize the forms discussed up to this point and the activities of which they are capable. These are the *radiocarpal joint (A),* the *metacarpophalangeal joints* from palm to finger *(B),* the wrist-thumb connection, the *carpometacarpal joint (C),* and the *intraphalangeal digit-to-digit joints (D).*
Each is capable of performing to a greater or lesser degree circular gyration, compression and extension backward and forward, and swinging or rocking from side to side. Study the drawings and use your own hand to discover the possibilities.

Note the arched arrangement of the carpals shown in the rear views. This concavity is formed by a transverse ligament *(E)* attached to the pisiform *(F)* and the hook of the hamate *(G)* at the outside and the crest of the trapezium *(H)* and the scaphoid *(I)* on the inside. Externally this ligament is not visible, but its function is to maintain the dome shape of the palm. You'll see this if you place your palm on a flat surface. You cannot flatten the palm center even if you press down.

RIGHT HAND, DORSAL VIEW

1. TENDON OF EXTENSOR CARPI ULNARIS
2. TENDONS OF EXTENSOR DIGITORUM COMMUNIS
3. HEAD OF ULNA
4. ANNULAR LIGAMENT
5. ORIGIN OF EXTENSOR CARPI ULNARIS
6. ABDUCTOR DIGITI MINIMI QUINTI
7. TENDON OF EXTENSOR DIGITI MINIMI
8. TENDONS OF EXTENSOR DIGITORUM COMMUNIS
9. TENDINOUS INTERJUNCTURES

10. INTERPHALANGEAL WEBBING
11. FINGERS:
 FIRST, POLLEX (THUMB)
 SECOND, INDEX
 THIRD, MEDIUS (MIDDLE)
 FOURTH, DIGITUS ANNULARIS (RING)
 FIFTH, DIGITUS MINIMUS (LITTLE)
12. FINGER PADS, PALMAR SURFACE
13. ABDUCTOR POLLICIS LONGUS
14. EXTENSOR POLLICIS BREVIS
15. STYLOID PROCESS OF RADIUS
16. TENDON OF EXTENSOR POLLICIS LONGUS
17. ORIGIN OF EXTENSOR CARPI RADIALIS LONGUS
18. BASE OF METACARPAL II
19. DORSAL INTEROSSEUS MUSCLES
20. ADDUCTOR POLLICIS
21. TENDON OF EXTENSOR INDICIS
22. FINGER PADS: THUMB, INDEX, PALMAR SURFACE

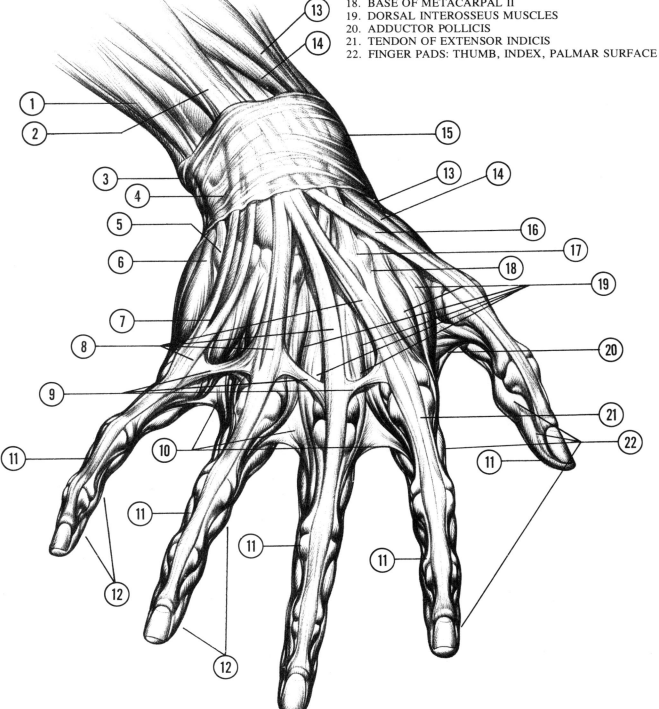

45

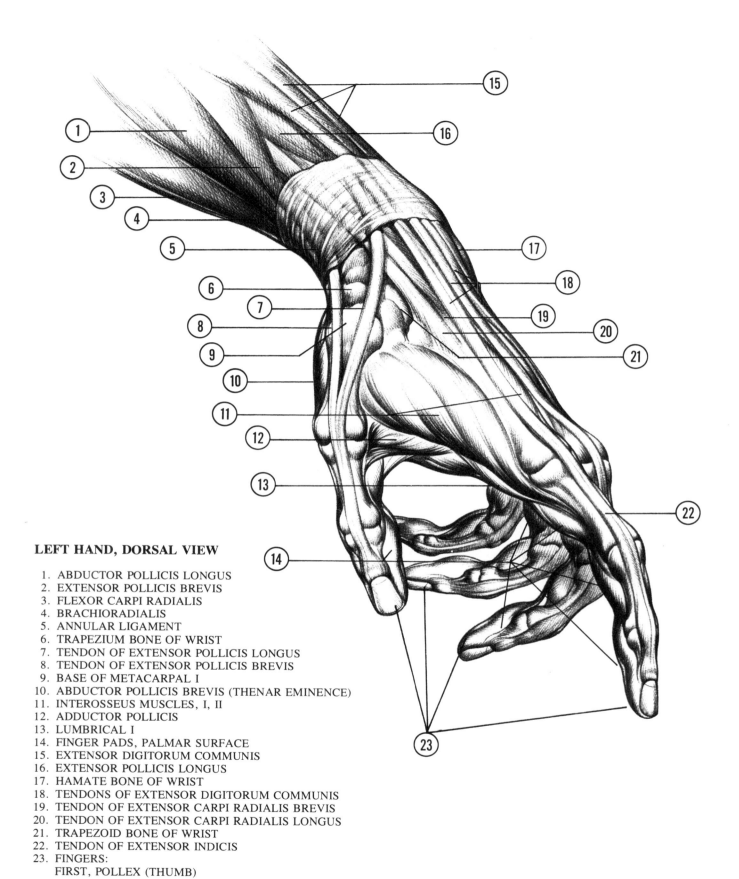

LEFT HAND, DORSAL VIEW

1. ABDUCTOR POLLICIS LONGUS
2. EXTENSOR POLLICIS BREVIS
3. FLEXOR CARPI RADIALIS
4. BRACHIORADIALIS
5. ANNULAR LIGAMENT
6. TRAPEZIUM BONE OF WRIST
7. TENDON OF EXTENSOR POLLICIS LONGUS
8. TENDON OF EXTENSOR POLLICIS BREVIS
9. BASE OF METACARPAL I
10. ABDUCTOR POLLICIS BREVIS (THENAR EMINENCE)
11. INTEROSSEUS MUSCLES, I, II
12. ADDUCTOR POLLICIS
13. LUMBRICAL I
14. FINGER PADS, PALMAR SURFACE
15. EXTENSOR DIGITORUM COMMUNIS
16. EXTENSOR POLLICIS LONGUS
17. HAMATE BONE OF WRIST
18. TENDONS OF EXTENSOR DIGITORUM COMMUNIS
19. TENDON OF EXTENSOR CARPI RADIALIS BREVIS
20. TENDON OF EXTENSOR CARPI RADIALIS LONGUS
21. TRAPEZOID BONE OF WRIST
22. TENDON OF EXTENSOR INDICIS
23. FINGERS:
 FIRST, POLLEX (THUMB)
 SECOND, INDEX
 THIRD, MEDIUS (MIDDLE)
 FOURTH, DIGITUS ANNULARIS (RING)

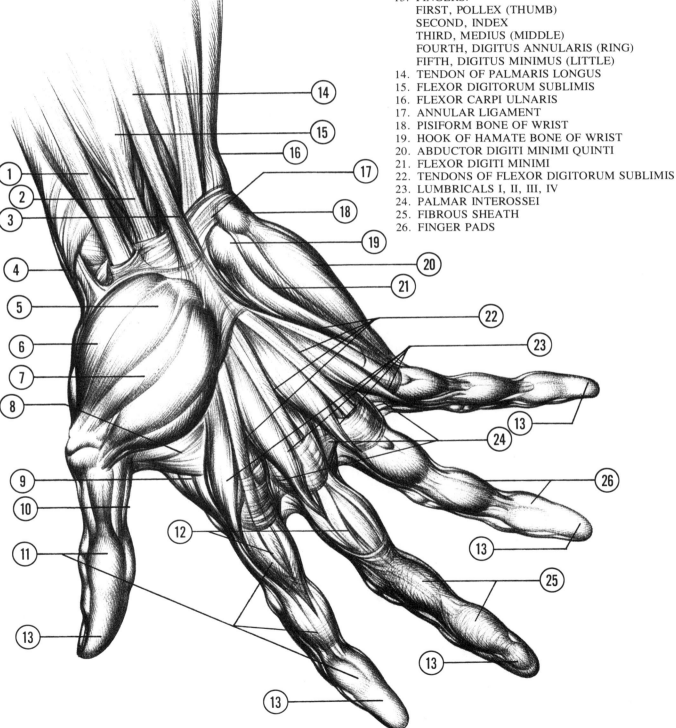

RIGHT HAND, PALMAR ASPECT

1. TENDON OF FLEXOR CARPI RADIALIS
2. FLEXOR DIGITORUM SUBLIMIS
3. TENDON OF PALMARIS LONGUS
4. EMINENCE OF RADIAL BONE
5. OPPONENS POLLICIS
6. ABDUCTOR POLLICIS BREVIS
7. FLEXOR POLLICIS BREVIS
8. ADDUCTOR POLLICIS TRANSVERSUS
9. DORSAL INTEROSSEUS I
10. TENDON OF FLEXOR POLLICIS LONGUS
11. FINGER PADS
12. SHEATH FOR FLEXOR TENDONS
13. FINGERS:
 FIRST, POLLEX (THUMB)
 SECOND, INDEX
 THIRD, MEDIUS (MIDDLE)
 FOURTH, DIGITUS ANNULARIS (RING)
 FIFTH, DIGITUS MINIMUS (LITTLE)
14. TENDON OF PALMARIS LONGUS
15. FLEXOR DIGITORUM SUBLIMIS
16. FLEXOR CARPI ULNARIS
17. ANNULAR LIGAMENT
18. PISIFORM BONE OF WRIST
19. HOOK OF HAMATE BONE OF WRIST
20. ABDUCTOR DIGITI MINIMI QUINTI
21. FLEXOR DIGITI MINIMI
22. TENDONS OF FLEXOR DIGITORUM SUBLIMIS
23. LUMBRICALS I, II, III, IV
24. PALMAR INTEROSSEI
25. FIBROUS SHEATH
26. FINGER PADS

LEFT HAND, DORSAL ASPECT, SIDE VIEW

1. EXTENSOR DIGITORUM COMMUNIS
2. ANNULAR LIGAMENT
3. EMINENCE OF LUNATE BONE OF WRIST
4. TRIQUETRUM BONE OF WRIST
5. HAMATE BONE OF WRIST
6. ORIGIN OF TENDON OF EXTENSOR CARPI ULNARIS
7. BASE OF METACARPAL V
8. DORSAL INTEROSSEUS
9. TENDINOUS INTERJUNCTURE
10. TENDONS OF EXTENSOR DIGITORUM COMMUNIS
11. FINGER PADS
12. FINGERS:
 FIRST, POLLEX (THUMB)
 SECOND, INDEX
 THIRD, MEDIUS (MIDDLE)
 FOURTH, DIGITUS ANNULARIS (RING)
 FIFTH, DIGITUS MINIMUS (LITTLE)
13. EXTENSOR CARPI ULNARIS
14. FLEXOR CARPI ULNARIS
15. HEAD OF ULNA
16. FLEXOR DIGITORUM SUBLIMIS
17. PALMARIS LONGUS
18. PISIFORM BONE OF WRIST
19. THENAR EMINENCE
20. OPPONENS POLLICIS
21. ABDUCTOR POLLICIS
22. FLEXOR POLLICIS BREVIS
23. HYPOTHENAR EMINENCE
24. ABDUCTOR DIGITI MINIMI QUINTI
25. FINGER PADS OF THUMB
26. INTERPHALANGEAL WEBBING

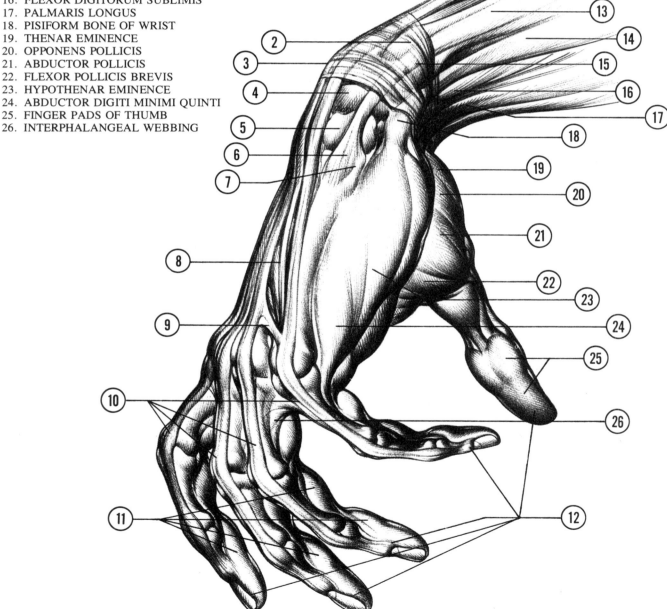

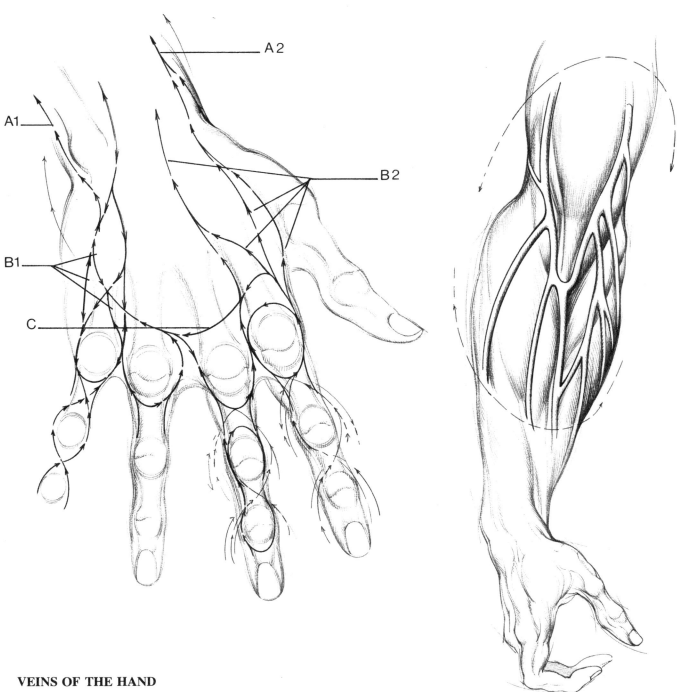

VEINS OF THE HAND

Blood vessels through the body tend to lie in depressions, generally in hollows between elevated forms. They are thus in a position of safety, out of the way of impact or injury. This is particularly true of the hand, where no veins protrude on the palmar side and where they tend to lie between forms on the dorsal side. The drawing at left shows the venous network coursing around the elevated knuckles, circling and crossing the finger shanks, and rising along the side planes of the fingers. Higher up, the venous system branches off into two main trunks *(A1, A2)* and two main tributaries *(B1, B2)* ascending vertically from a transverse channel, the *dorsal venous arch (C)* above the palm knuckles.

The drawing at right, with arm extended downward, shows the location of veins along the main muscles of the inner arm. Note their deep entrenchment, especially at the elbow.

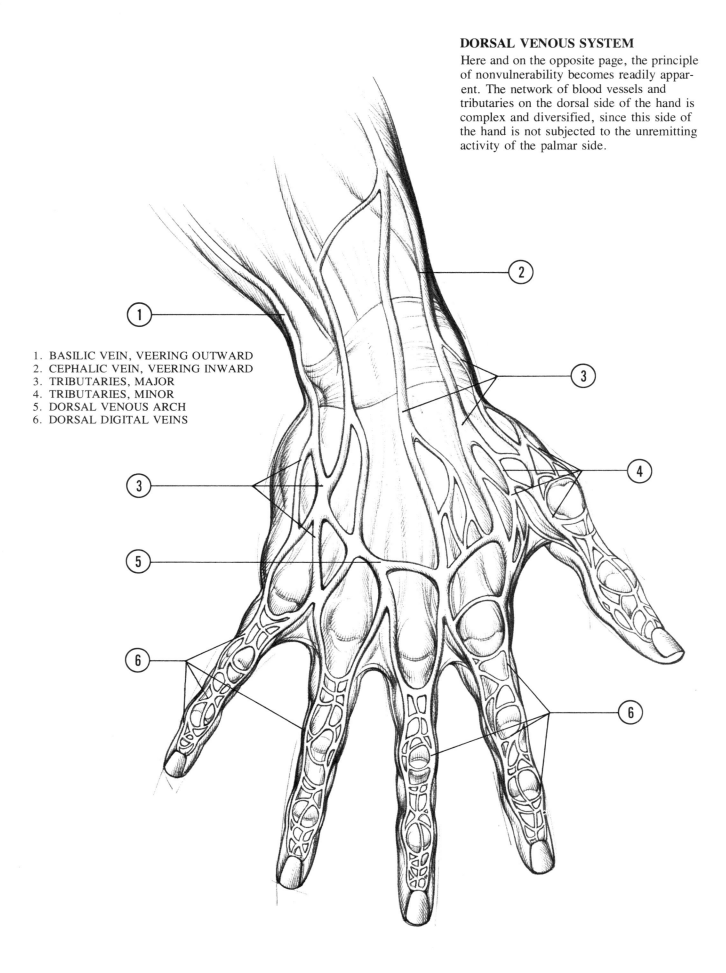

DORSAL VENOUS SYSTEM

Here and on the opposite page, the principle of nonvulnerability becomes readily apparent. The network of blood vessels and tributaries on the dorsal side of the hand is complex and diversified, since this side of the hand is not subjected to the unremitting activity of the palmar side.

1. BASILIC VEIN, VEERING OUTWARD
2. CEPHALIC VEIN, VEERING INWARD
3. TRIBUTARIES, MAJOR
4. TRIBUTARIES, MINOR
5. DORSAL VENOUS ARCH
6. DORSAL DIGITAL VEINS

PALMAR VENOUS SYSTEM

Conversely, the palmar venous system is markedly simpler than that of the dorsal side, especially in the fingers. This system allows for the flexing, closing, and clenching actions of the inner hand, with the extremes of pressure encountered through a working day.

1. CEPHALIC VEIN
2. MEDIAN VEIN
3. TRIBUTARIES TO BASILIC VEIN
4. TRANSVERSE PALMAR ARCH
5. LONGITUDINAL DIGITAL VEINS

4.
ANATOMICAL LANDMARKS AND SURFACE STRESS

The artist can truly understand surface forms only by knowing their underlying structures and their form and behavior under tension, stress, and activity. We are still dealing with anatomy in this chapter, but from the viewpoint of dominant surface stress.

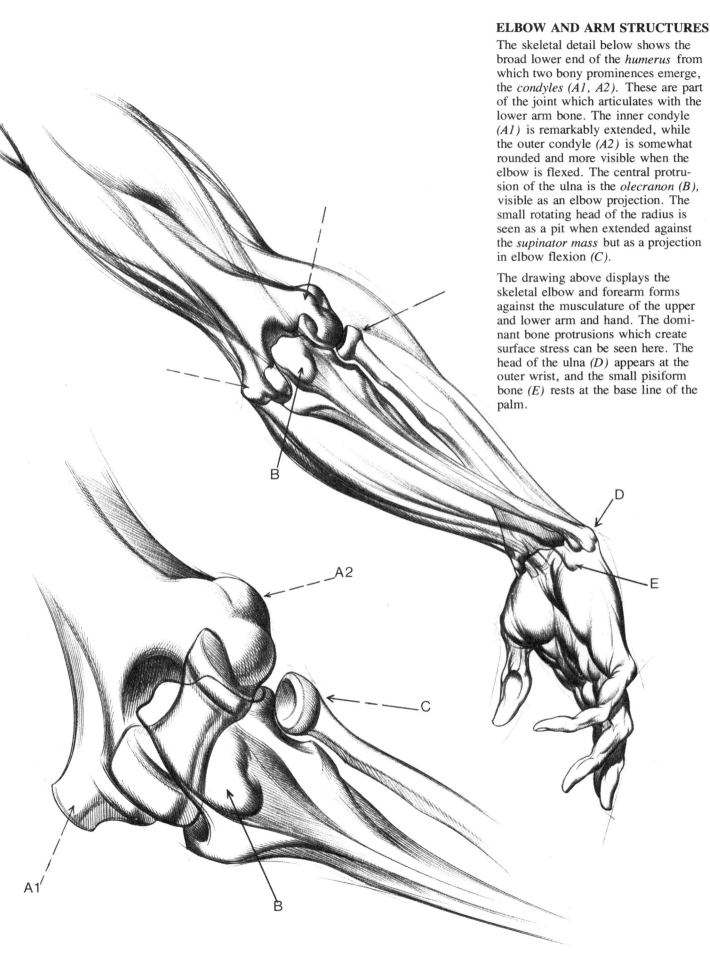

ELBOW AND ARM STRUCTURES

The skeletal detail below shows the broad lower end of the *humerus* from which two bony prominences emerge, the *condyles (A1, A2)*. These are part of the joint which articulates with the lower arm bone. The inner condyle *(A1)* is remarkably extended, while the outer condyle *(A2)* is somewhat rounded and more visible when the elbow is flexed. The central protrusion of the ulna is the *olecranon (B)*, visible as an elbow projection. The small rotating head of the radius is seen as a pit when extended against the *supinator mass* but as a projection in elbow flexion *(C)*.

The drawing above displays the skeletal elbow and forearm forms against the musculature of the upper and lower arm and hand. The dominant bone protrusions which create surface stress can be seen here. The head of the ulna *(D)* appears at the outer wrist, and the small pisiform bone *(E)* rests at the base line of the palm.

SIDE PLANE OF WRIST AND LITTLE FINGER

This drawing of the little finger side of the hand shows the wrist and the head of the ulna in two views. The top view illustrates alignment of the ulnar head with the palm knuckle of the little finger from both top and side planes. The pisiform bone can be seen under the head of the ulna. The lower drawing shows these forms with the hand turned palm side up. Note that when placement of the little finger knuckle and palm is known, all other knuckles on the dorsal side of the hand can also be determined correctly.

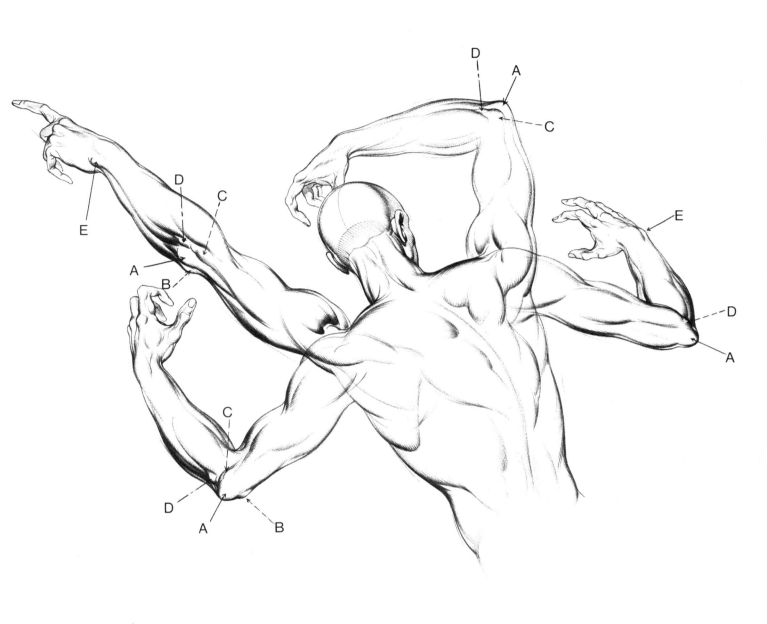

SKELETAL ELBOW AND WRIST PROJECTIONS

This multiple action drawing illustrates the necessity of knowing underlying structure and surface stress. Note the five skeletal projections of elbow and wrist which become apparent under the stress of the positions shown. These are elbow (olecranon) projection *(A)*, inner condyle projection *(B)*, outer condyle projection *(C)*, radius head *(D)*, and ulnar head, side plane projection *(E)*. See if you can locate other anatomical landmarks in the hand and elsewhere.

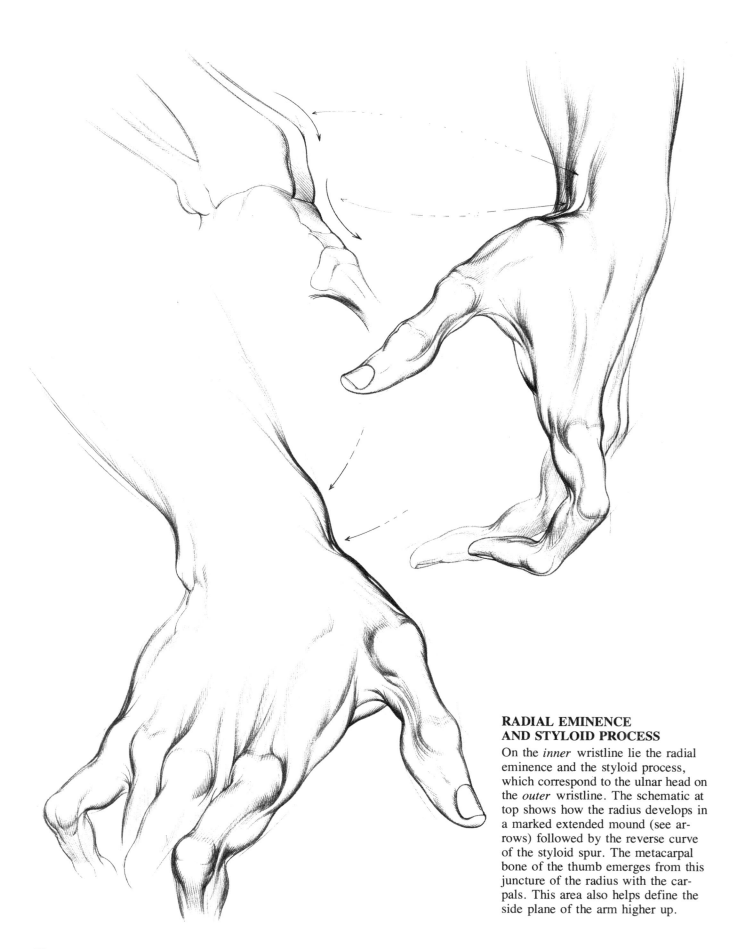

RADIAL EMINENCE AND STYLOID PROCESS

On the *inner* wristline lie the radial eminence and the styloid process, which correspond to the ulnar head on the *outer* wristline. The schematic at top shows how the radius develops in a marked extended mound (see arrows) followed by the reverse curve of the styloid spur. The metacarpal bone of the thumb emerges from this juncture of the radius with the carpals. This area also helps define the side plane of the arm higher up.

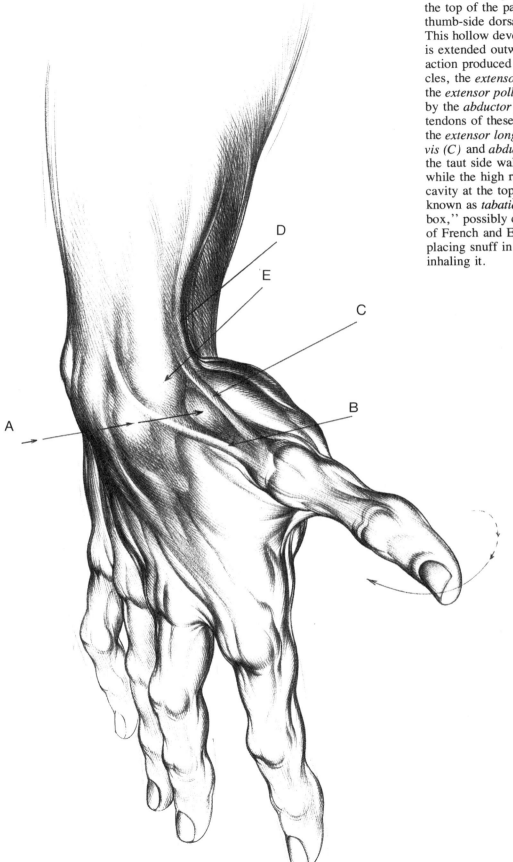

THE "SNUFFBOX"

Note the triangular depression high in the top of the palm *(A)* shown in this thumb-side dorsal view of the hand. This hollow develops when the thumb is extended outward and upward, an action produced by two thumb muscles, the *extensor pollicis longus* and the *extensor pollicis brevis,* and aided by the *abductor pollicis longus.* The tendons of these muscles noted here, the *extensor longus (B), extensor brevis (C)* and *abductor longus (D)* form the taut side walls of this depression, while the high radius *(E)* closes the cavity at the top. This depression is known as *tabatière,* meaning "snuffbox," possibly derived from the habit of French and English gentlemen placing snuff in this hollow and then inhaling it.

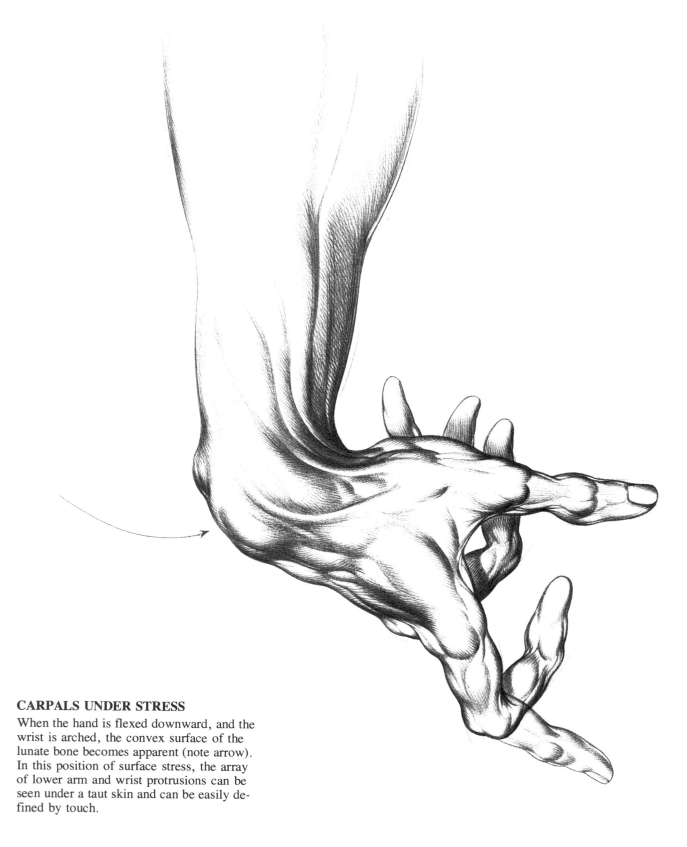

CARPALS UNDER STRESS

When the hand is flexed downward, and the wrist is arched, the convex surface of the lunate bone becomes apparent (note arrow). In this position of surface stress, the array of lower arm and wrist protrusions can be seen under a taut skin and can be easily defined by touch.

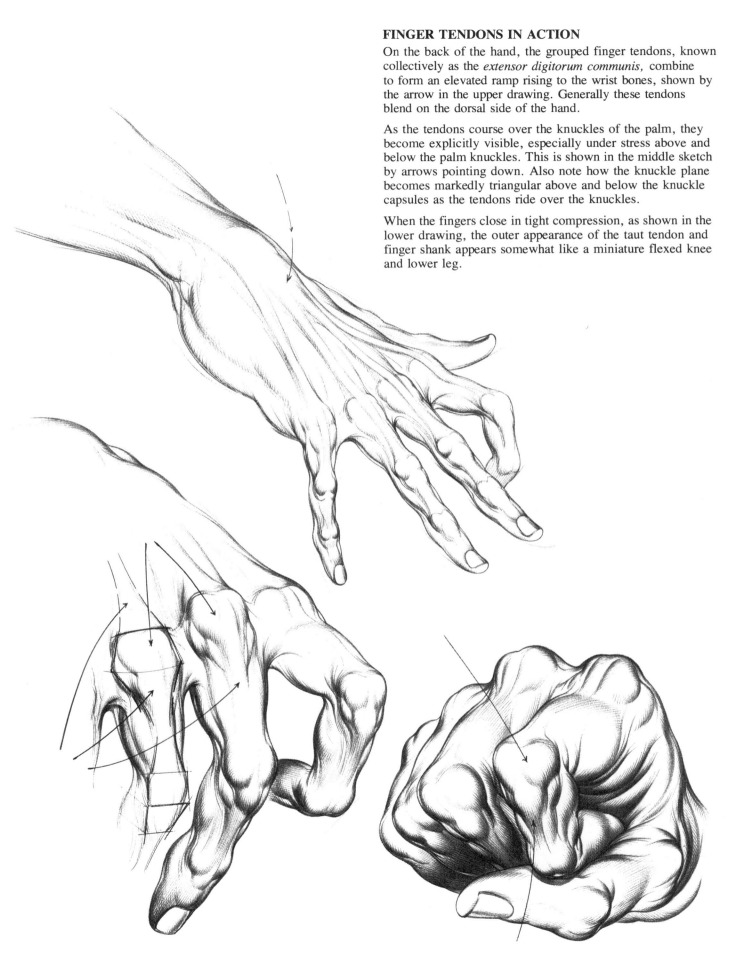

FINGER TENDONS IN ACTION

On the back of the hand, the grouped finger tendons, known collectively as the *extensor digitorum communis,* combine to form an elevated ramp rising to the wrist bones, shown by the arrow in the upper drawing. Generally these tendons blend on the dorsal side of the hand.

As the tendons course over the knuckles of the palm, they become explicitly visible, especially under stress above and below the palm knuckles. This is shown in the middle sketch by arrows pointing down. Also note how the knuckle plane becomes markedly triangular above and below the knuckle capsules as the tendons ride over the knuckles.

When the fingers close in tight compression, as shown in the lower drawing, the outer appearance of the taut tendon and finger shank appears somewhat like a miniature flexed knee and lower leg.

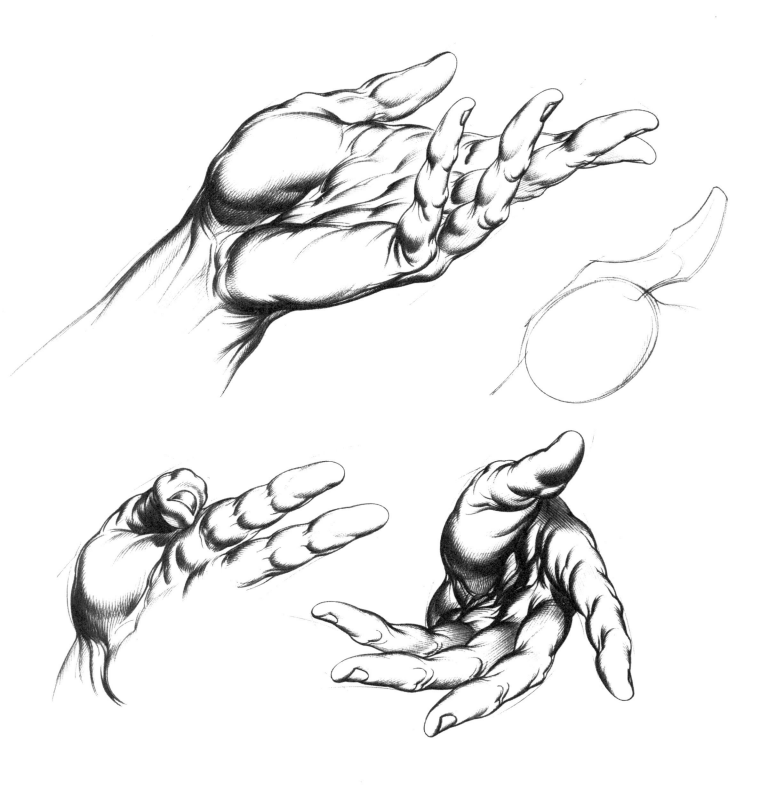

THENAR EMINENCE

The ball of the thumb (thenar eminence) is the largest form on the underside of the palm. Shaped like an egg (as shown in the upper palmar view and the schematic to its right), it is notably variable as it flexes and closes toward the palm. It will flatten when lying tightly flexed against the index finger, but will elevate and expand when the thumb rises and begins to rotate inward toward the palm, as shown in the drawing at lower right.

HYPOTHENAR PLATEAU

Opposite the thenar eminence is the flatter, more elongated hypothenar plateau (noted by arrows) on the little finger side of the palm. This is seen from the side plane in the upper drawings. Wedge shaped, it rises narrowly from the little finger metacarpal pad and swells upward to the wrist.

The drawing below, little finger side up, shows the higher thenar eminence on the other side of the deep trench at mid-palm. This mid-palm trench (marked by broken arrows) is a unique landmark in the hand, for it centrally divides the palm, running from the tip of the longest finger to the apex of the palm at the wrist. Even beyond, it ascends the forearm on the midline tendon of *palmaris longus*.

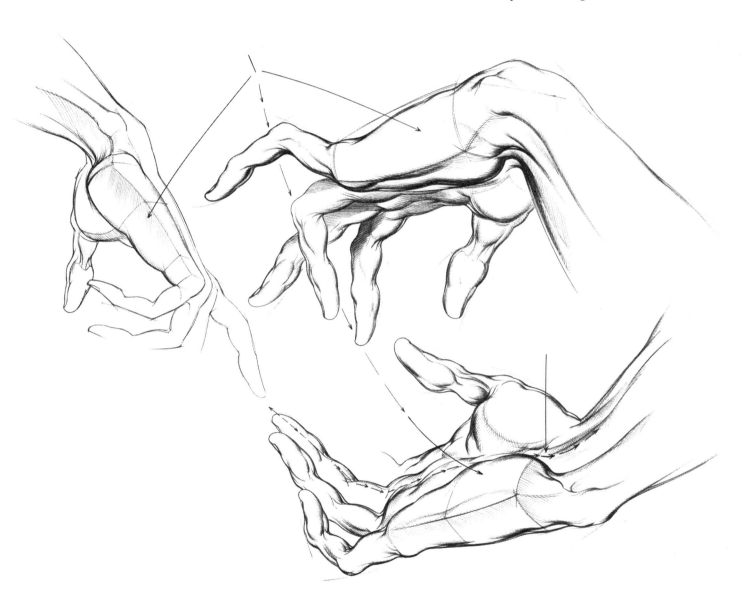

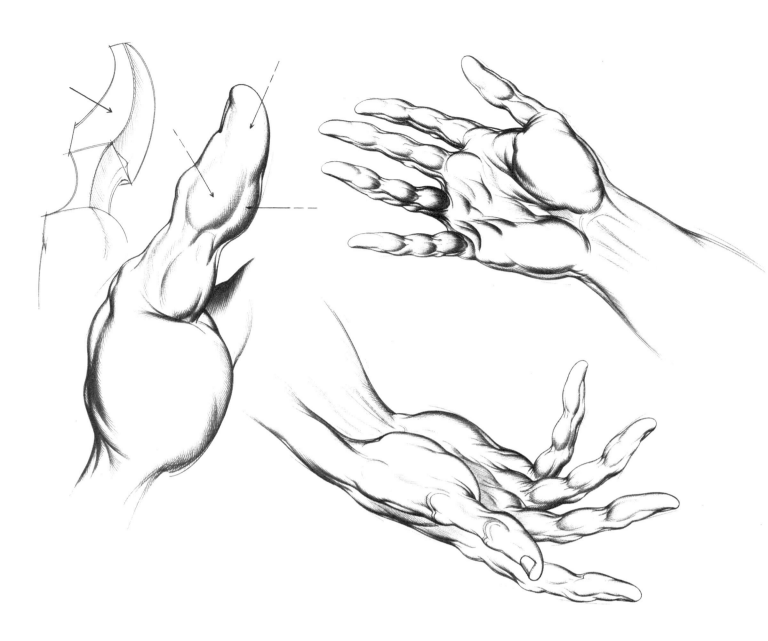

FINGERTIP AND FINGER SHANK PADS

Consistent with the wedge shape of all fingertip forms, the thumb pads, marked by arrows in the large drawing at left, form an isosceles triangle. This is true for all other fingertips as well.

The pads on the finger shanks, seen in the drawings of the open palm, are somewhat lozenge shaped, yet are lightly creased at the center because of the deep flexor tendons running the length of the fingers. Note the variations of fingertip and finger shank pads seen from these two different views.

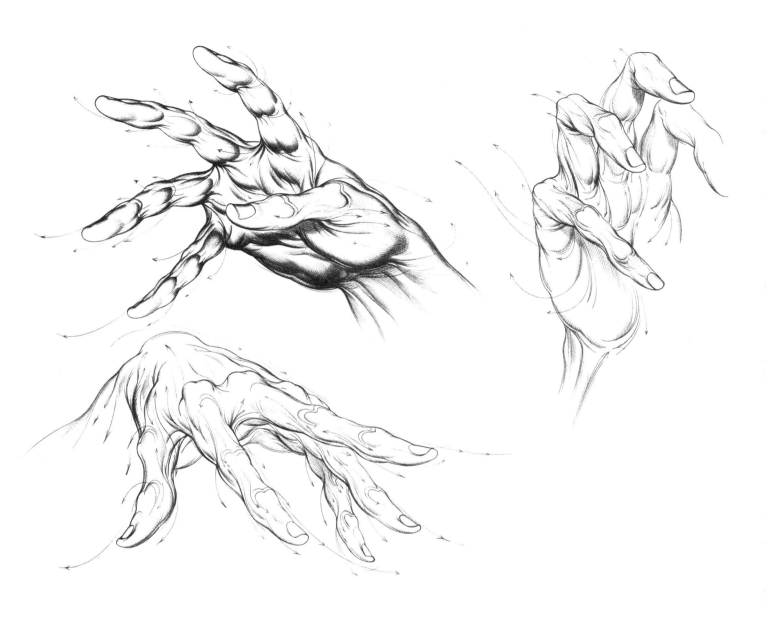

STRESSES AND ENERGY FLOWS

When the hand is in motion or performing an activity, the skin is stressed in the direction of the action, responding to the stress in the same way that clothing responds to the action of the body. Note the arrows expressing the spiraling swings of the fingers in the drawing at upper left. Follow the backward stress as the thumb surges forward and note the creases at the wrist.

The arrows in the drawing at lower left express the skin tensions on the curved knuckle capsules and illustrate the conception of the drawing. They express energy flows and the dynamics that shape the drawing.

The drawing at upper right shows the direction of stress on finger pads and the palm during bends and thrusts. Also note the webs between the fingers which connect the finger roots without slowing or inhibiting movement.

5.
ACTIONS, FUNCTIONS, LIMITS OF MOVEMENT

The hand is the most complex and variable form in the human body. No other form can respond with such extraordinary range and functional capability and with such ease and grace. For example, the separate fingers can perform an immense variety of actions, and the thumb, obliquely opposing the four long fingers and palm wedge, aids in actions such as grasping, prying, and supporting. However, not all the forms of the hand are as free to move as the fingers. Some forms are bound tightly by ligaments and have a very limited range of movement. In this chapter we will look at the hand in terms of some of the many maneuvers of which it is capable.

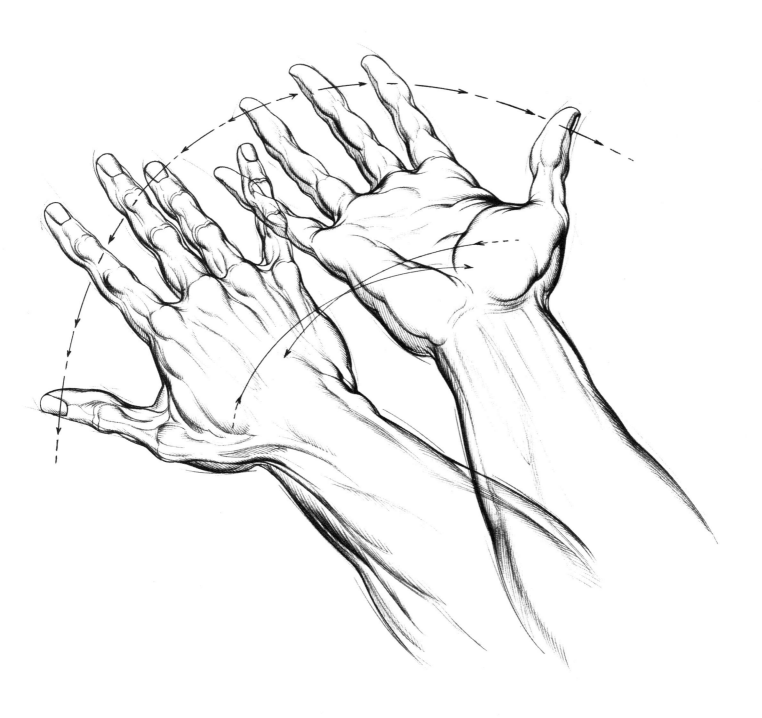

PALM ROTATION

One of the hand's unique actions is palm rotation. It rotates in a 180-degree arc, a full half circle. The drawing at left, with thumb in, shows pronation, and the one at right, with thumb out, shows supination. This is a simple action with the arm outstretched, but not so simple when the arm changes position. Put your hand to your head, shoulder, back, leg, or ankle, and rotate it. Note the difficulty in different positions.

DOWNWARD PALM BEND

When the palm bends downward with the fingers extended, the ultimate declination from the line of the forearm is an angle of 90 degrees—a right angle. The point at which the arm stops and the hand begins is shown by the horizontal arrow, the wristline juncture of the arm, *not* the carpal line of the hand.

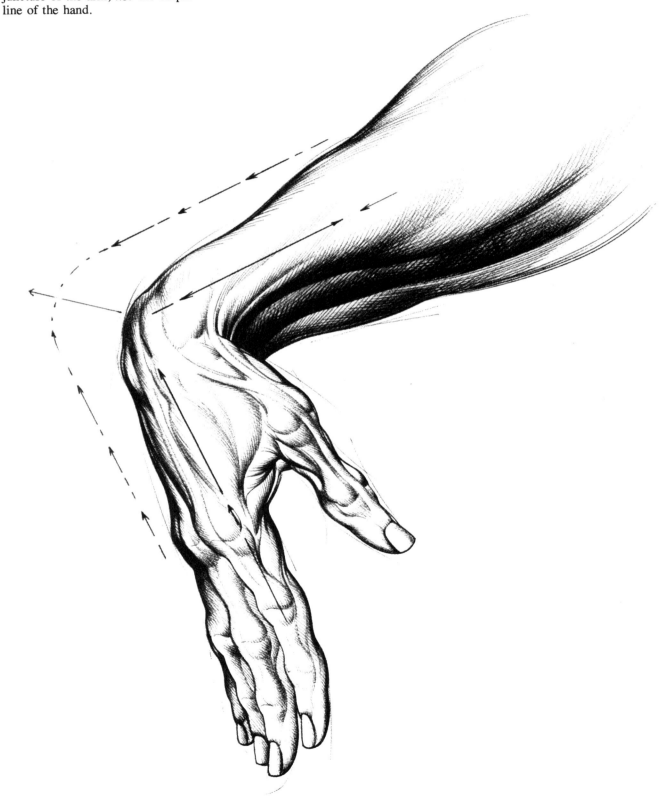

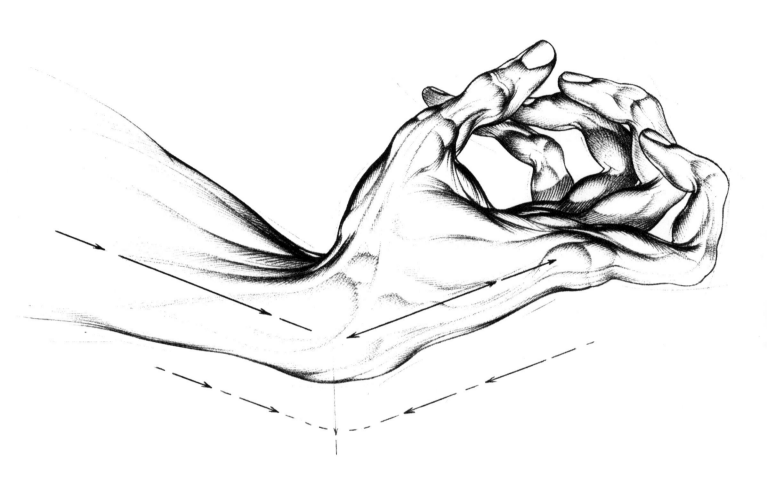

UPWARD PALM BEND

When the fingers flex and bend inward to the palm, the angle of palm-to-forearm is only 45 degrees. The juncture point is shown by the vertical arrow.

ANGLE OF PALM ELEVATION

When the palm bends upward at the wrist with fingers extended, as shown in the upper sketch, the line of elevation from the horizontal arm will rise to an angle of 45 to 50 degrees. The vertical arrow indicates the point of direction change. Yet when the fingers close or are tightly clenched, the angle of elevation from wrist to metacarpals is not affected. Note the correspondence of angles in lower and upper drawings. The reason the palm will not change its angle of elevation, whether the fingers are open or closed, is due to the tightly flexed elevators of the palm, the *extensors carpi radialis* and *carpi ulnaris*. When the fingers close *inward,* the muscle grouping of the finger extensors *(extensor digitorum) flattens out* on the *top* side of the arm. Hence the space for muscle expansion is in no way inhibited. In fact, it is even greater because of the flexing of the palm elevators.

Check back on the preceding drawing for palm flexion *inward* and note the difference. In that drawing, finger flexion creates an effective rise in the finger muscle mass of the under forearm, resulting in the inhibition of the palm flexors against the sizeable central muscle mass.

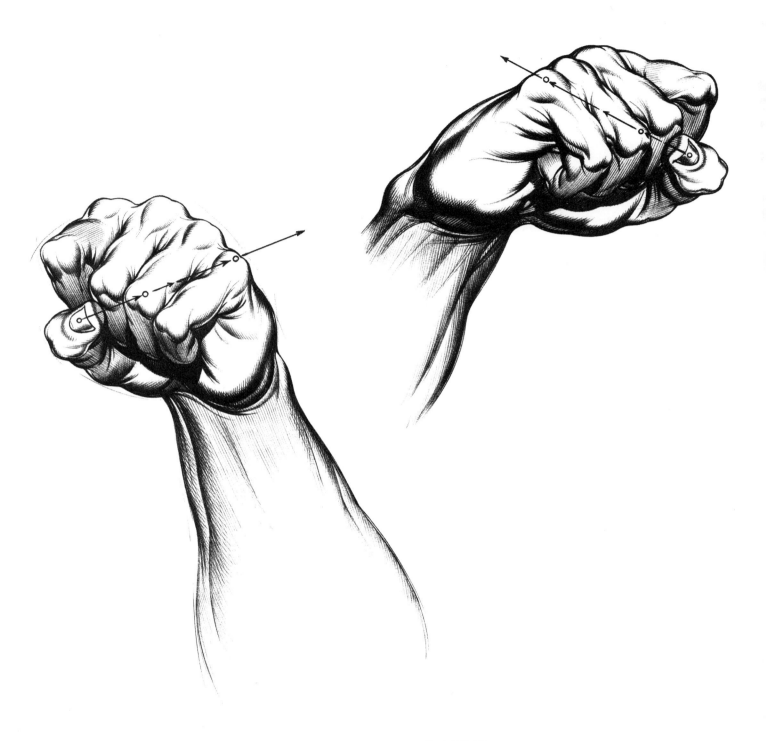

FIST CLOSURE

In the closed fist, it is important to note the correct orientation of the thumb in opposition to the fingers. In right closure the thumb tip will abut the shank of the middle phalanx of the long finger just below the closed knuckle. The line of thumb direction (shown by broken arrows) points diagonally from the place of middle finger contact across the center of the fourth finger knuckle toward the intersection of the little finger palm knuckle.

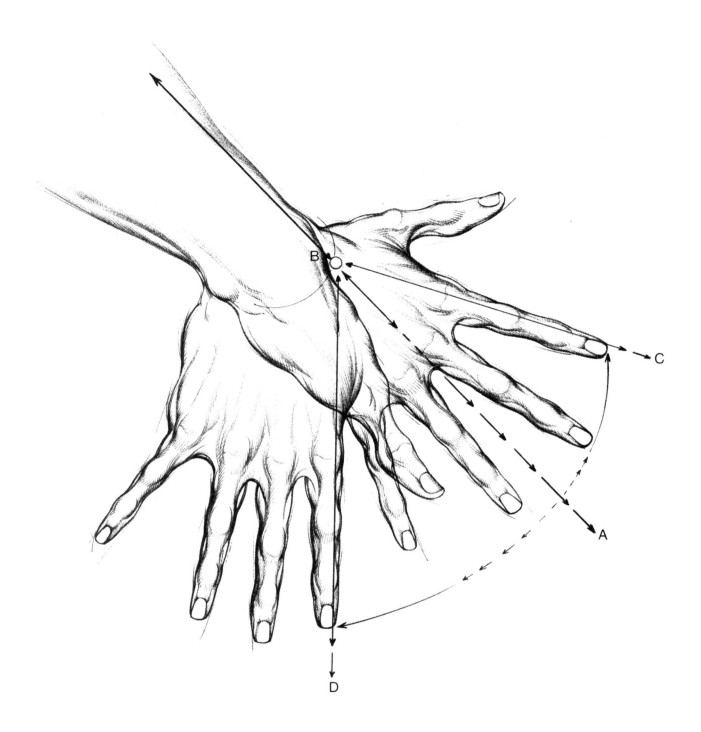

INSIDE AND OUTSIDE ANGLES

The drawing here illustrates the swing of the hand from extreme inside to extreme outside positions. The hand is placed on a flat surface, palm side down, with the pivot position at zero. The broken line *(A)*, continuing from the inner arm line *(B)*, represents the line of the index finger in normal position. When the index finger line swings inward *(C)* the angle will be approximately 30 degrees from line *B*. When the index finger swings outward (whole palm of course), the angle will be 45 degrees from *A* to *D*. Thus the total swing of the palm from inside to outside will be an arc of 75 degrees from *C* to *D*.

SIDE VIEW ANGLES

Seen from the side view, when the thumb lies relaxed and adjacent to the side of the palm and index finger (hold up your hand and observe), the angle of the tipped thumb will be about 30 to 35 degrees from the vertical side plane of the palm and finger (shown by vertical arrows). The tipped thumb is defined here from the angle of the fingernail, the planes of the knuckles, the phalanx, and the metacarpal. Note how this angle of tipping is consistent if the thumb is brought down, but will *not* hold if the thumb is brought inward or under the palm.

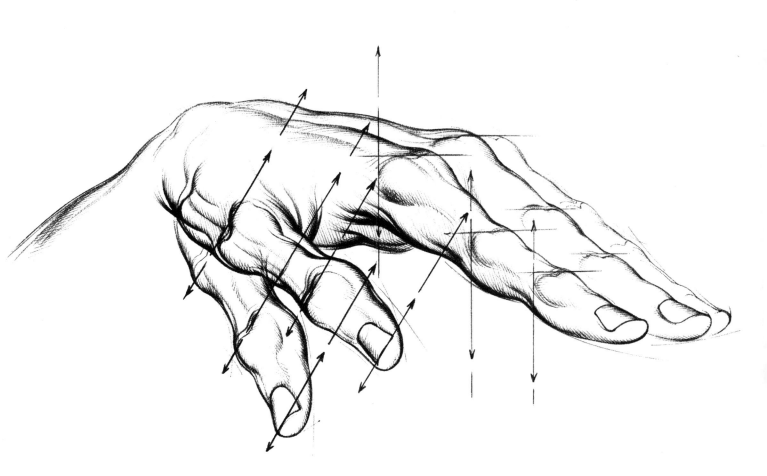

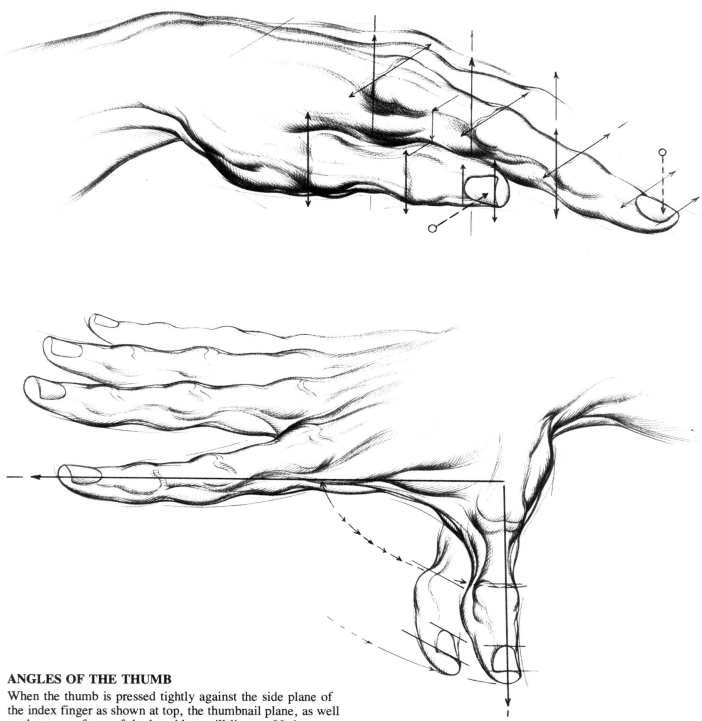

ANGLES OF THE THUMB

When the thumb is pressed tightly against the side plane of the index finger as shown at top, the thumbnail plane, as well as the top surfaces of the knuckles, will lie at a 90-degree angle to the top of the hand and the index finger knuckles and fingernail. Note the contraposed angles of the fingernails of thumb and index finger.

The thumb is shown in complete extension in the lower drawing. Notice that at a full 90-degree angle the thumb fingernail lies fully *horizontal* with the flat surface planes of the other fingernails. Also, at this point of maximum extension, the thumb and forefinger make a true right angle to each other.

THUMB ROTATION

This drawing shows the hand from a three-quarter palm position. As the thumb swings out, the thumbnail plane rotates upward from a 90-degree vertical position at tight closure (note vertical arrows), to a 60-degree position (middle thumb position), and then to a 45-degree angle.

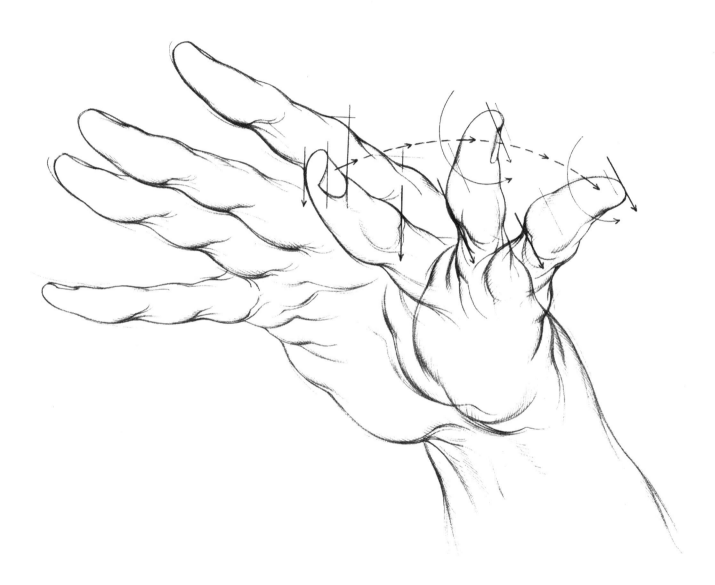

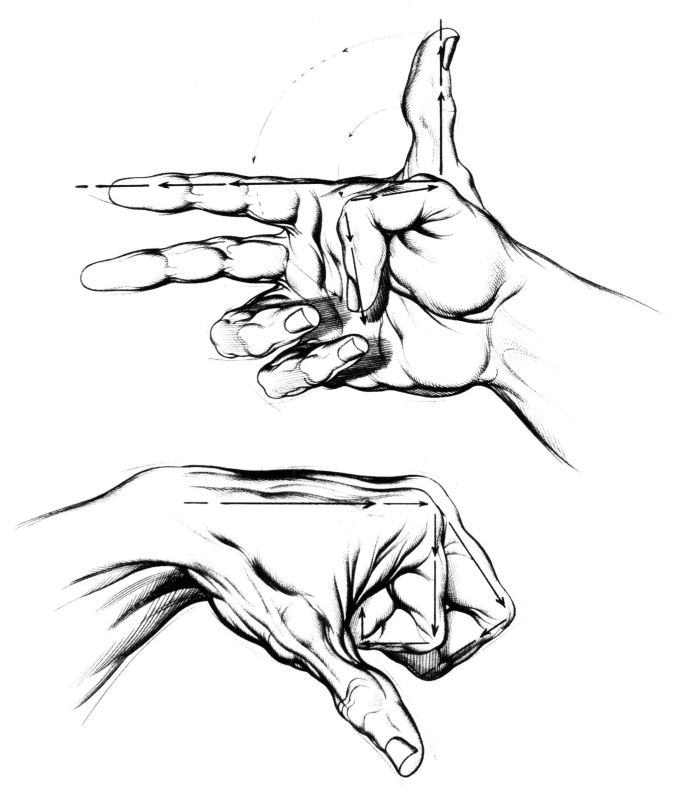

FINGER ANGLES

All fingers tend to show a general 90-degree limit of closure,
knuckle to knuckle, from the thumb through the little finger.
The sketch above shows the thumb pointed out 90 degrees
from the palm line and then drawn down and closed at 90
degrees. Both positions form right angles with the index
finger. The sketch below shows the index finger in tight flex-
ion, producing a square corner at every knuckle bend. Note
the 90-degree bends in the middle finger.

TOP VIEW

The upper sketch, drawn from above, shows the thumb closed at a 90-degree angle dipping *below* the level of the index finger. It will not go further down without breaking the 90-degree thumb closure. Also note the horizontal alignment of index finger and thumb. In the sketch below, the back fingers in closure also form 90-degree angles at each knuckle.

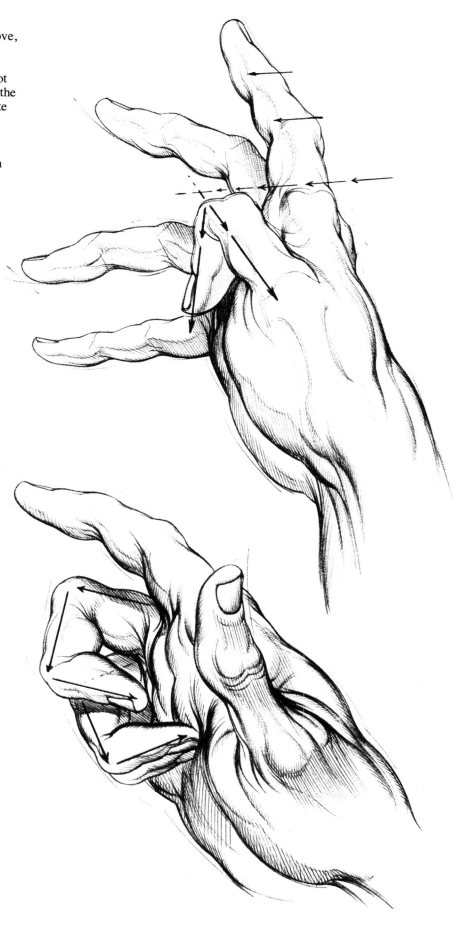

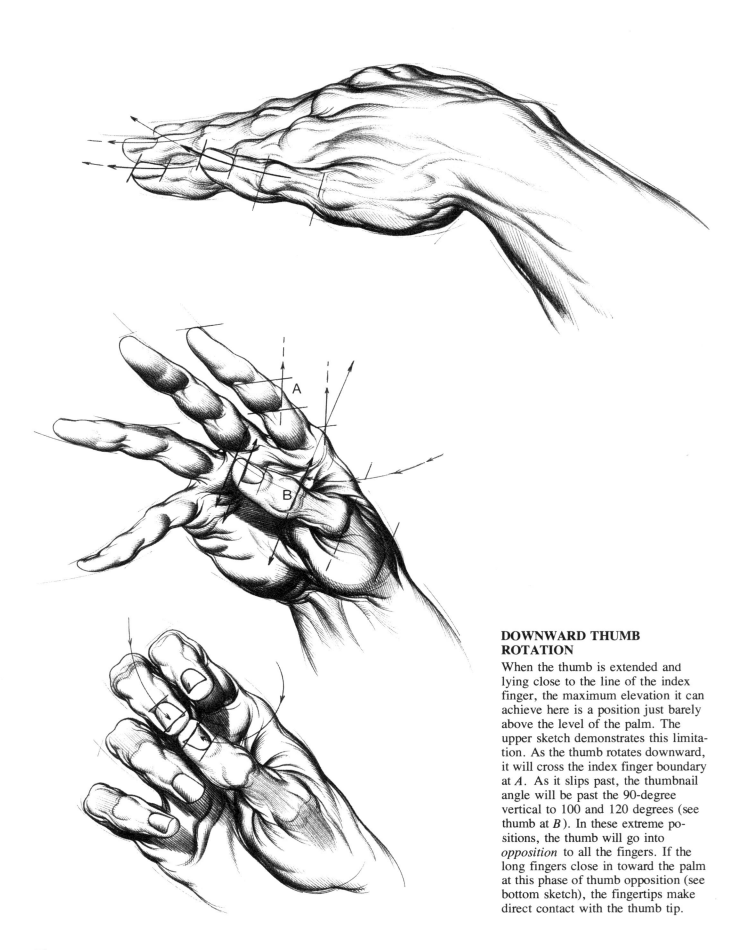

DOWNWARD THUMB ROTATION

When the thumb is extended and lying close to the line of the index finger, the maximum elevation it can achieve here is a position just barely above the level of the palm. The upper sketch demonstrates this limitation. As the thumb rotates downward, it will cross the index finger boundary at *A*. As it slips past, the thumbnail angle will be past the 90-degree vertical to 100 and 120 degrees (see thumb at *B*). In these extreme positions, the thumb will go into *opposition* to all the fingers. If the long fingers close in toward the palm at this phase of thumb opposition (see bottom sketch), the fingertips make direct contact with the thumb tip.

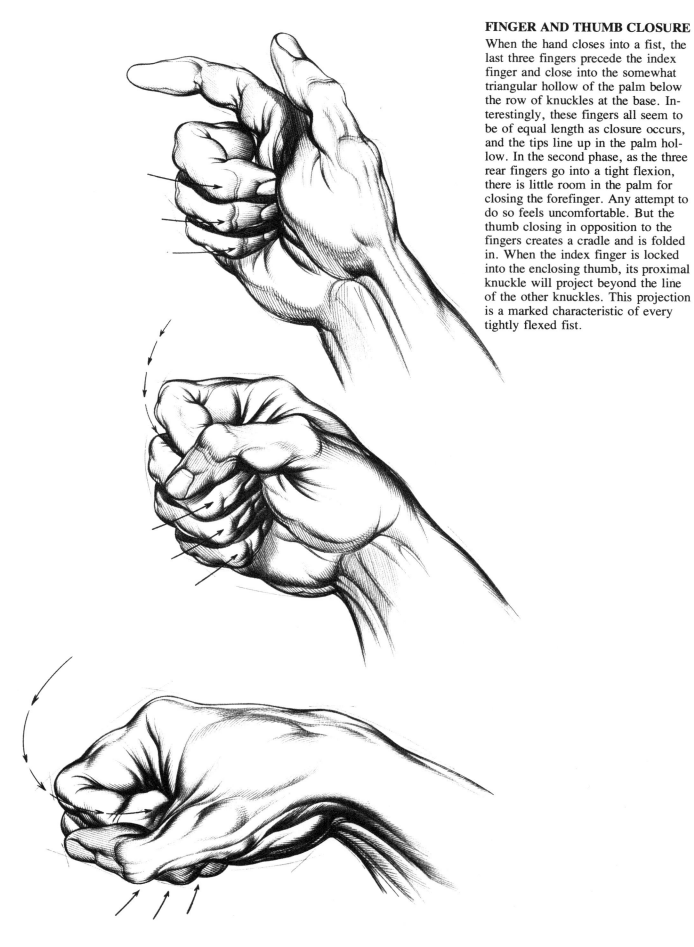

FINGER AND THUMB CLOSURE

When the hand closes into a fist, the last three fingers precede the index finger and close into the somewhat triangular hollow of the palm below the row of knuckles at the base. Interestingly, these fingers all seem to be of equal length as closure occurs, and the tips line up in the palm hollow. In the second phase, as the three rear fingers go into a tight flexion, there is little room in the palm for closing the forefinger. Any attempt to do so feels uncomfortable. But the thumb closing in opposition to the fingers creates a cradle and is folded in. When the index finger is locked into the enclosing thumb, its proximal knuckle will project beyond the line of the other knuckles. This projection is a marked characteristic of every tightly flexed fist.

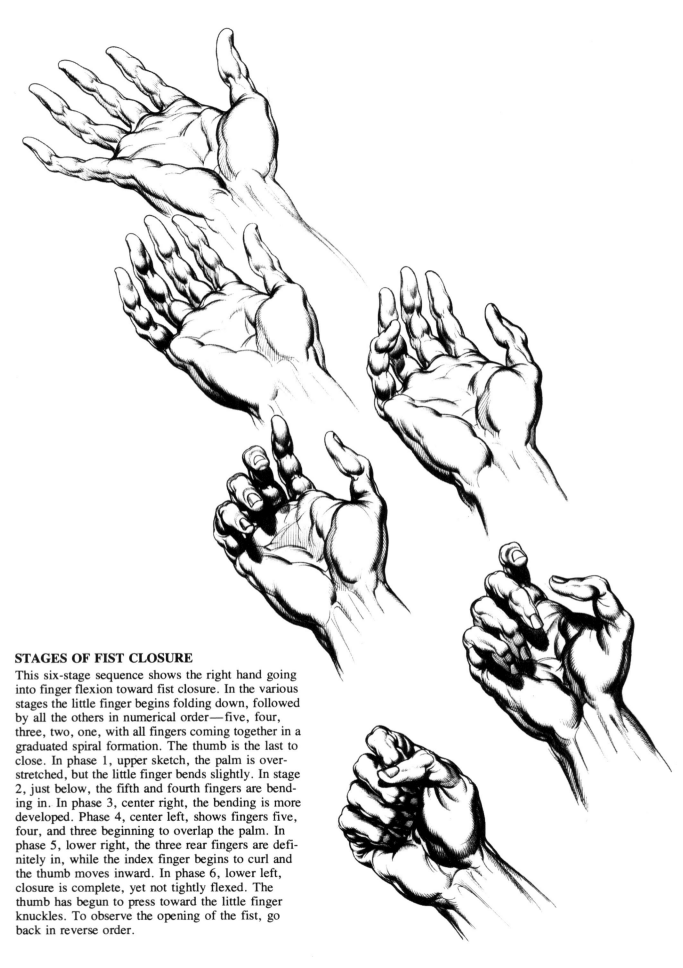

STAGES OF FIST CLOSURE

This six-stage sequence shows the right hand going into finger flexion toward fist closure. In the various stages the little finger begins folding down, followed by all the others in numerical order—five, four, three, two, one, with all fingers coming together in a graduated spiral formation. The thumb is the last to close. In phase 1, upper sketch, the palm is over-stretched, but the little finger bends slightly. In stage 2, just below, the fifth and fourth fingers are bending in. In phase 3, center right, the bending is more developed. Phase 4, center left, shows fingers five, four, and three beginning to overlap the palm. In phase 5, lower right, the three rear fingers are definitely in, while the index finger begins to curl and the thumb moves inward. In phase 6, lower left, closure is complete, yet not tightly flexed. The thumb has begun to press toward the little finger knuckles. To observe the opening of the fist, go back in reverse order.

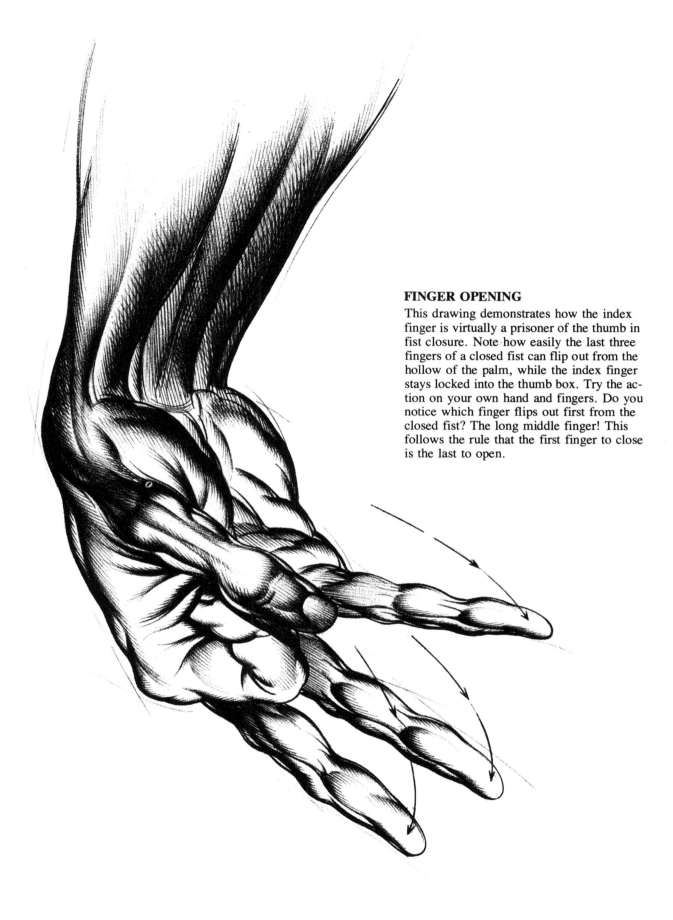

FINGER OPENING

This drawing demonstrates how the index finger is virtually a prisoner of the thumb in fist closure. Note how easily the last three fingers of a closed fist can flip out from the hollow of the palm, while the index finger stays locked into the thumb box. Try the action on your own hand and fingers. Do you notice which finger flips out first from the closed fist? The long middle finger! This follows the rule that the first finger to close is the last to open.

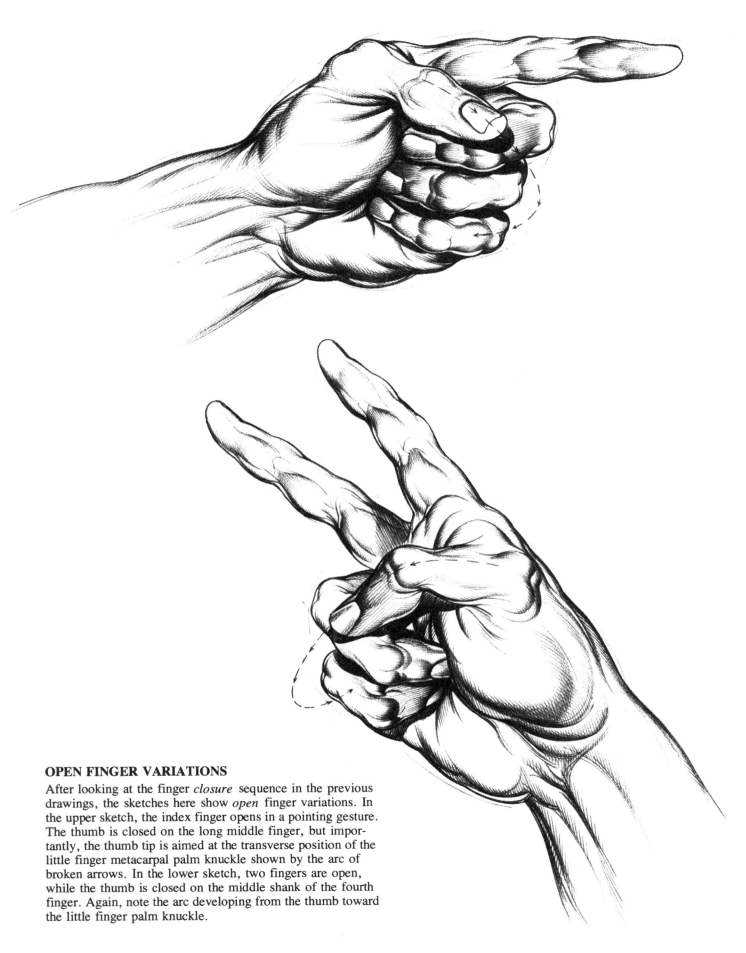

OPEN FINGER VARIATIONS

After looking at the finger *closure* sequence in the previous
drawings, the sketches here show *open* finger variations. In
the upper sketch, the index finger opens in a pointing gesture.
The thumb is closed on the long middle finger, but impor-
tantly, the thumb tip is aimed at the transverse position of the
little finger metacarpal palm knuckle shown by the arc of
broken arrows. In the lower sketch, two fingers are open,
while the thumb is closed on the middle shank of the fourth
finger. Again, note the arc developing from the thumb toward
the little finger palm knuckle.

THREE-FINGER OPENING

With three fingers open, the thumb is closed on the middle phalanx of the fifth finger. Note the consistency of the transverse line of the thumb toward the fifth palm knuckle, with the tip of the little finger resting in the palm trench.

6.
FORESHORTENING

It is impossible to draw the human hand accurately and artistically without an understanding of foreshortening, the overlapping of forms seen in spatial recession. Because there is scarcely any hand position which does not involve some form seen in deep space, in order to achieve a three-dimensional rather than a flat effect, it is important to see and understand advancing and receding forms. A difficulty often encountered is the problem of retaining the hand's rhythms, its flow, and its sense of unity when drawing it from angles of deep foreshortening. Because forms are seen one in front of, on top of, or behind another, or not clearly seen at all, there is a tendency for them to look bumpy, segmented, and abrupt. Principles such as overlapping, interlacing, spiraling, and tonal contrast to achieve depth are given here as aids to learning to draw the hand as a dynamic, alive volume moving in space.

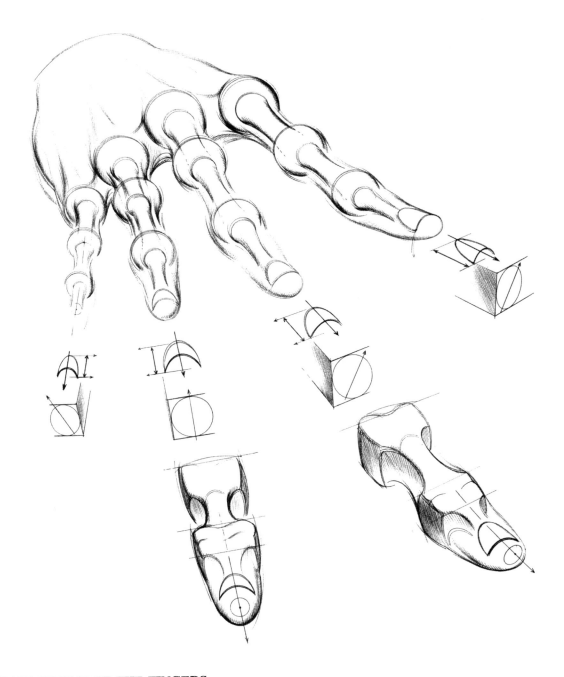

ROD AND BALL FORMS OF THE FINGERS

Using the simple ball (knuckle) and rod (shank) forms we have studied earlier, note that the three rods (shanks) of the index finger appear quite long in this three-quarter view. We see the other fingers more straight on, as we move progressively to the left. The rods or bone shanks are seen as shortest, especially the rear shank, on the fourth finger. This is due to a foreshortening or compression of frontal space. One of the ways to test the accuracy of the drawings of foreshortened fingers is to check the fingernail *lengths* seen in depth against the *curves* in the different views from side to front as shown in the middle diagrams.

Beginning with the side view at right, the nail appears more sidewise than frontal. It seems long from front to back (note arrows), and the curve is quite elliptical. In the schematic block in front of the nail, the circle is seen as an ellipse because of the tangential view, and the top of the ellipse has the same kind of curve as the nail arch. The nail of the long

middle finger is more circular because its tip is seen more to the front. It is also shorter from front to back, and the nail is less elliptical and more curved, as shown by the schematic block. The fourth finger is seen from the deepest view of all, its tip seen at almost full circle with the nail fully arched. Conversely, the nail length is also the shortest of all because of the deepest foreshortening. Note the full circle on the schematic block. The little finger is veering left of center, and the slight side view gives a somewhat elliptical nail arch at front.

The two sketches at bottom show the knuckle and shank forms in the terminals of the middle and fourth fingers. Compare the front view of the fourth finger with the tangential view of the middle finger. The fourth finger looks short and circular, while the middle finger looks long and elliptical. Also note how the fingertips and nails reflect the views of the fingers.

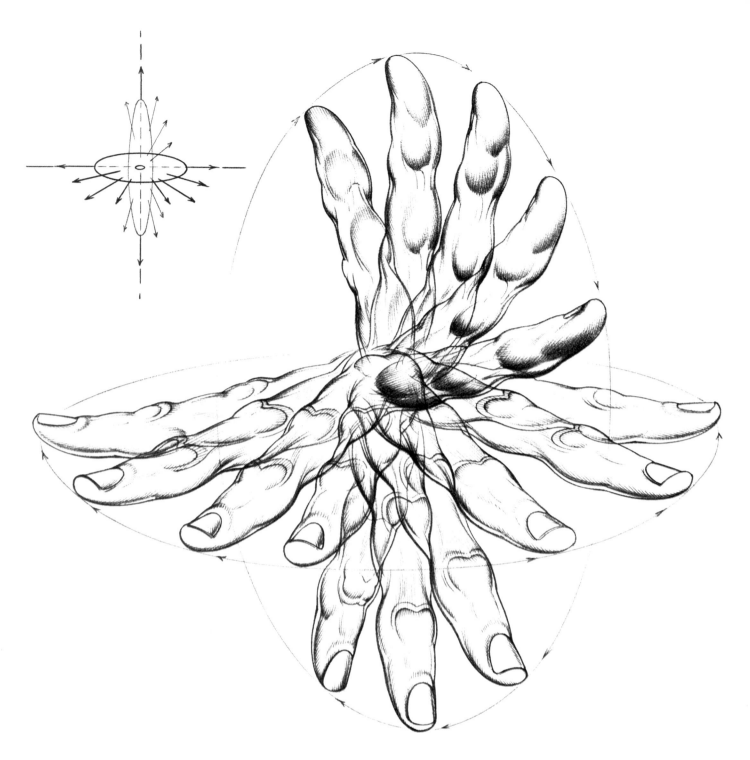

FORESHORTENING IN ROTATION

The drawing here is a wonderful exercise in foreshortening, using just the single long middle finger. The finger is seen in rotation in two directions—on a horizontal plane from side to side and on a vertical plane from top to bottom. The rotation scheme is given in miniature in the diagram at upper left.

On the horizontal axis, the *shorter* the radius, the *deeper* the foreshortened view of the finger, producing *shorter* finger shank lengths but *rounder* nails and knuckles. *The concept here is that cylindrical forms become circular in foreshortening.* This is also true for fingers in vertical rotation. As before, any new finger in the downward progression becomes more circular as foreshortening occurs, and with the increase of spatial depth, the overlapping of curved elements also increases. It will be profitable to study slowly each of the phases on both planes shown here.

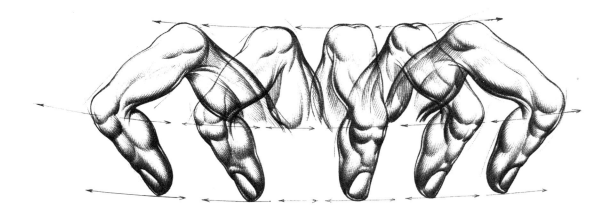

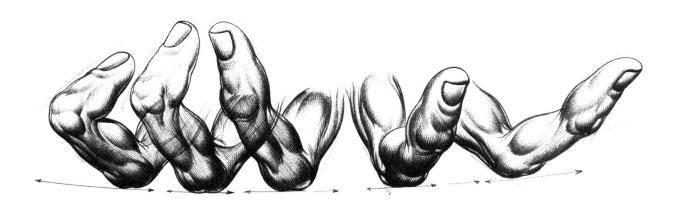

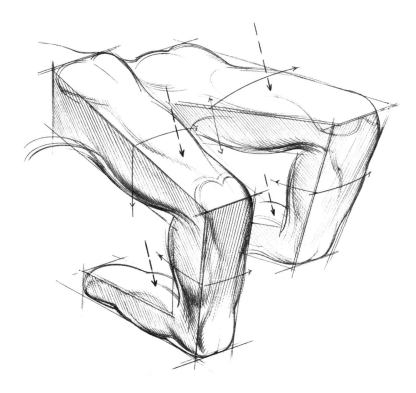

TONAL CHANGES TO ACHIEVE DEPTH

The use of tonal or value changes is an indispensable factor in the development of spatial recession. The drawing at lower left, showing top, side, and underplane surfaces of the two fingers, reveals that *advancing* surfaces seen horizontally are defined with light tones; *receding* surfaces which fall away to side planes are given intermediate tones; and *regressing* forms, such as underplanes, which lie farthest from the light, are expressed in deepest values. The tonal or value system shown in the sketch is simplified in order to permit the use of accented dark contours on undersurface areas.

The developed drawing in the center shows a sequence of a single bent finger moving in an arc of foreshortened changes. The advancing plane here is the middle phalanx of each finger. Thus the top surface is generally lightest. The intermediate surfaces are found mainly on side planes and small protrusions and are defined with grayish tones. The surfaces lying deepest are toned the darkest.

In the upper sequence, the single finger is turned around, with the fleshy palmar surface exposed to the light source. This finger is seen in various positions of the rotational swing. Thus the terminal phalanx may show lighter or darker values, depending on the advancing, receding, or regressing spatial direction.

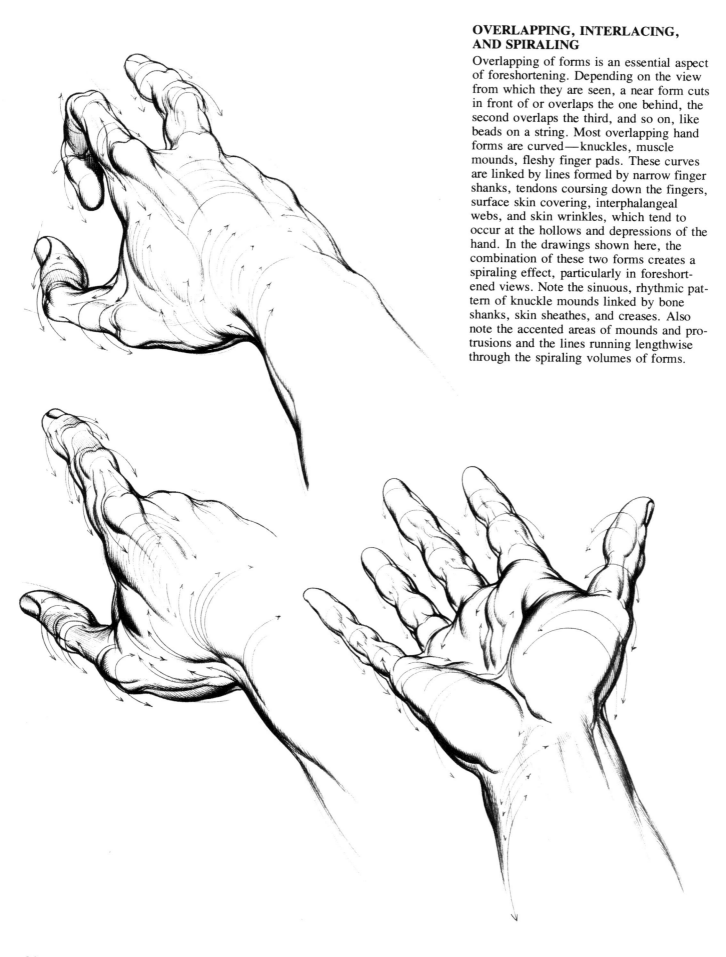

OVERLAPPING, INTERLACING, AND SPIRALING

Overlapping of forms is an essential aspect of foreshortening. Depending on the view from which they are seen, a near form cuts in front of or overlaps the one behind, the second overlaps the third, and so on, like beads on a string. Most overlapping hand forms are curved—knuckles, muscle mounds, fleshy finger pads. These curves are linked by lines formed by narrow finger shanks, tendons coursing down the fingers, surface skin covering, interphalangeal webs, and skin wrinkles, which tend to occur at the hollows and depressions of the hand. In the drawings shown here, the combination of these two forms creates a spiraling effect, particularly in foreshortened views. Note the sinuous, rhythmic pattern of knuckle mounds linked by bone shanks, skin sheaths, and creases. Also note the accented areas of mounds and protrusions and the lines running lengthwise through the spiraling volumes of forms.

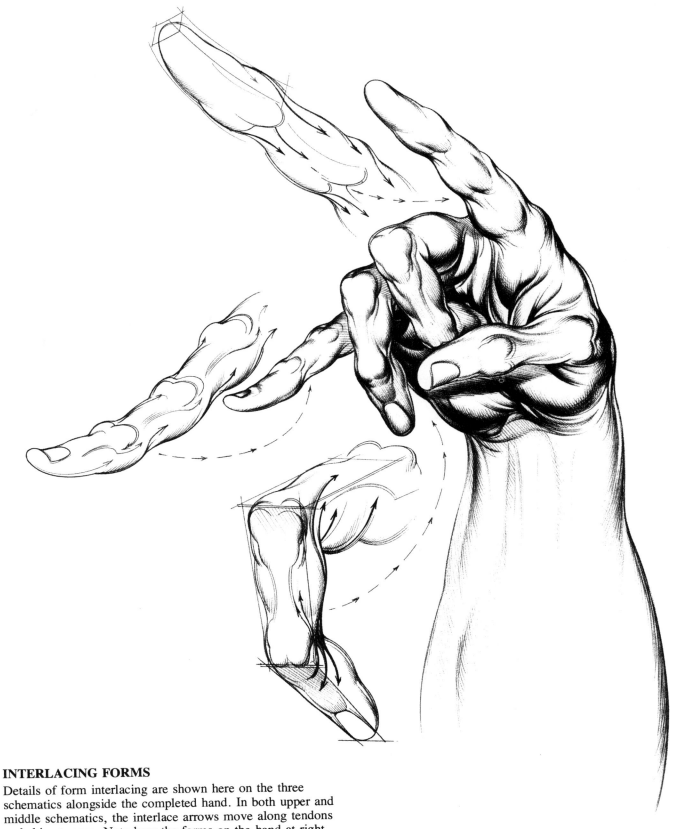

INTERLACING FORMS

Details of form interlacing are shown here on the three
schematics alongside the completed hand. In both upper and
middle schematics, the interlace arrows move along tendons
and skin stresses. Note how the forms on the hand at right
blend into an uninterrupted continuity. The lower schematic
shows sharply defined edges and planes along the interlacing
and spiraling arrows. Variation in values is used on the
finished hand to achieve depth. Note the darker tones on the
palm seen in deeper space as well as the cast shadows, which
indicate *overlapping* forms, *not connecting* ones.

VISUAL TENSION

Depth increases visual tension and impact when fingers contrapose each other, especially in overlapping. In this drawing, index finger and thumb are thrust left and out (note direction of arrows), while the rear fingers, less tense and darker, bend inward for contrast. The arm is also part of this leftward, energized thrust. Note how solid the near forms appear and how recessive the ones farther back seem.

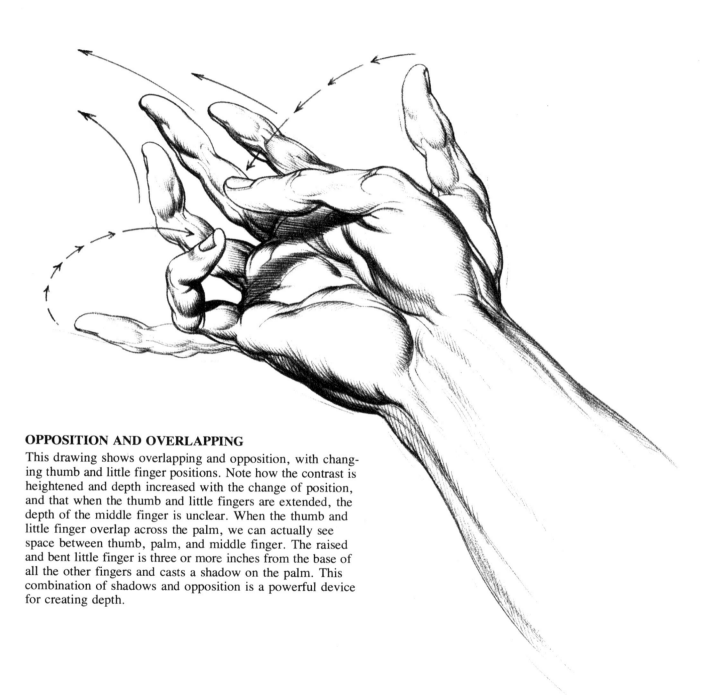

OPPOSITION AND OVERLAPPING

This drawing shows overlapping and opposition, with changing thumb and little finger positions. Note how the contrast is heightened and depth increased with the change of position, and that when the thumb and little fingers are extended, the depth of the middle finger is unclear. When the thumb and little finger overlap across the palm, we can actually see space between thumb, palm, and middle finger. The raised and bent little finger is three or more inches from the base of all the other fingers and casts a shadow on the palm. This combination of shadows and opposition is a powerful device for creating depth.

CONTRAPOSED FINGERS

This is another example of contraposed fingers moving in three contrary directions. The thumb and ring fingers in opposition to each other (see broken arrows) compress in tight contact, the ring finger underneath and bent into the palm, the thumb on top. Cast shadows, overlapping, and varying tones all help to illustrate depth. The two fingers extended outward and right and the little finger bent tautly inward and left express a diametrical cross-palm overlap. The extreme divergence excites the eye with its tension. Yet also note the recession of knuckles in a much less tense visual sequence.

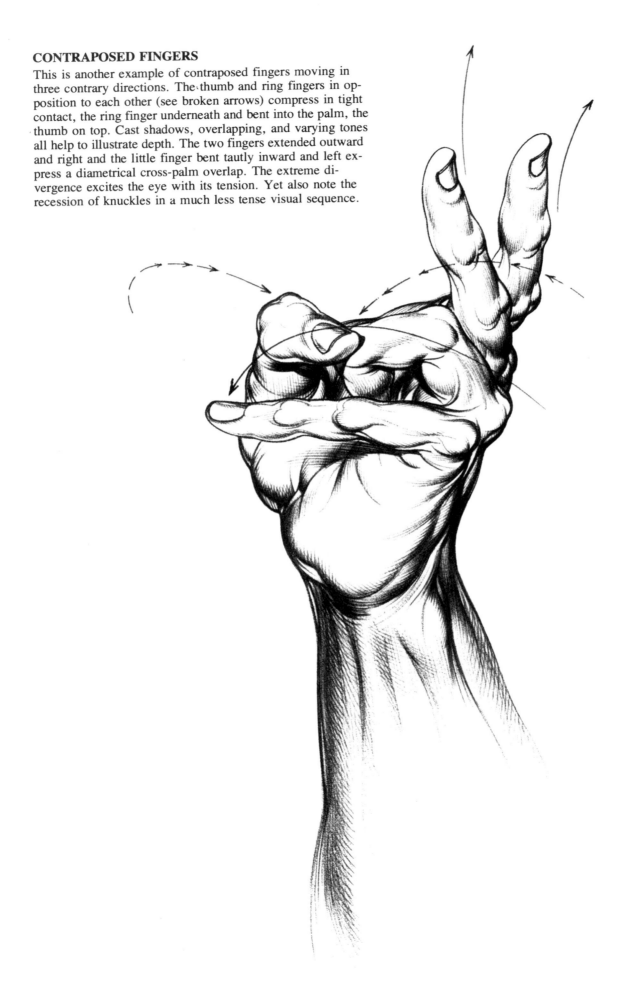

90

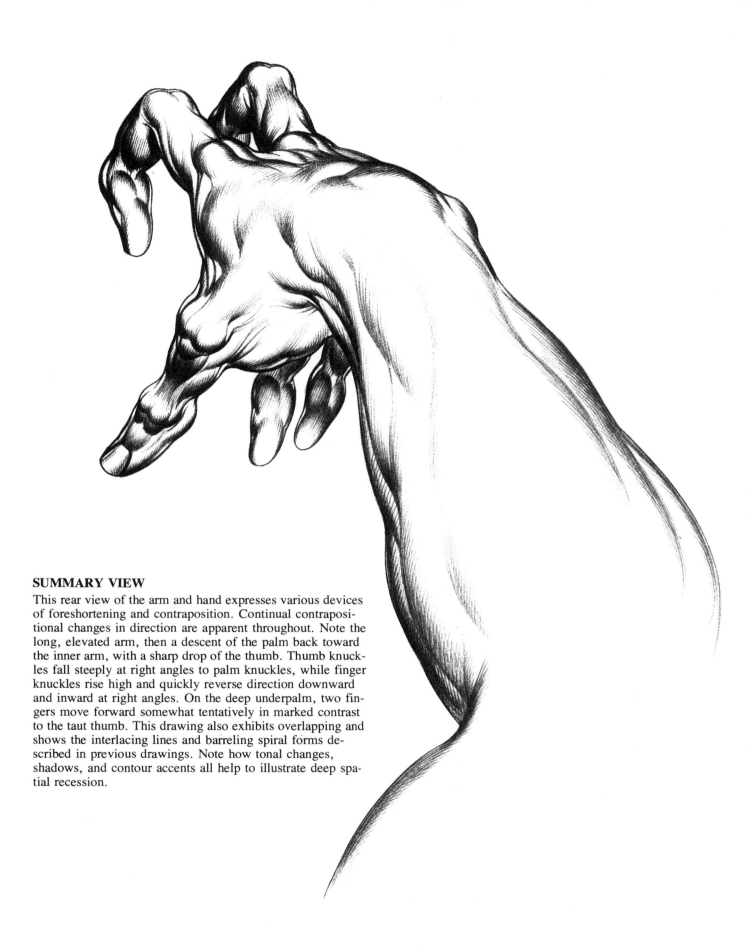

SUMMARY VIEW

This rear view of the arm and hand expresses various devices
of foreshortening and contraposition. Continual contraposi-
tional changes in direction are apparent throughout. Note the
long, elevated arm, then a descent of the palm back toward
the inner arm, with a sharp drop of the thumb. Thumb knuck-
les fall steeply at right angles to palm knuckles, while finger
knuckles rise high and quickly reverse direction downward
and inward at right angles. On the deep underpalm, two fin-
gers move forward somewhat tentatively in marked contrast
to the taut thumb. This drawing also exhibits overlapping and
shows the interlacing lines and barreling spiral forms de-
scribed in previous drawings. Note how tonal changes,
shadows, and contour accents all help to illustrate deep spa-
tial recession.

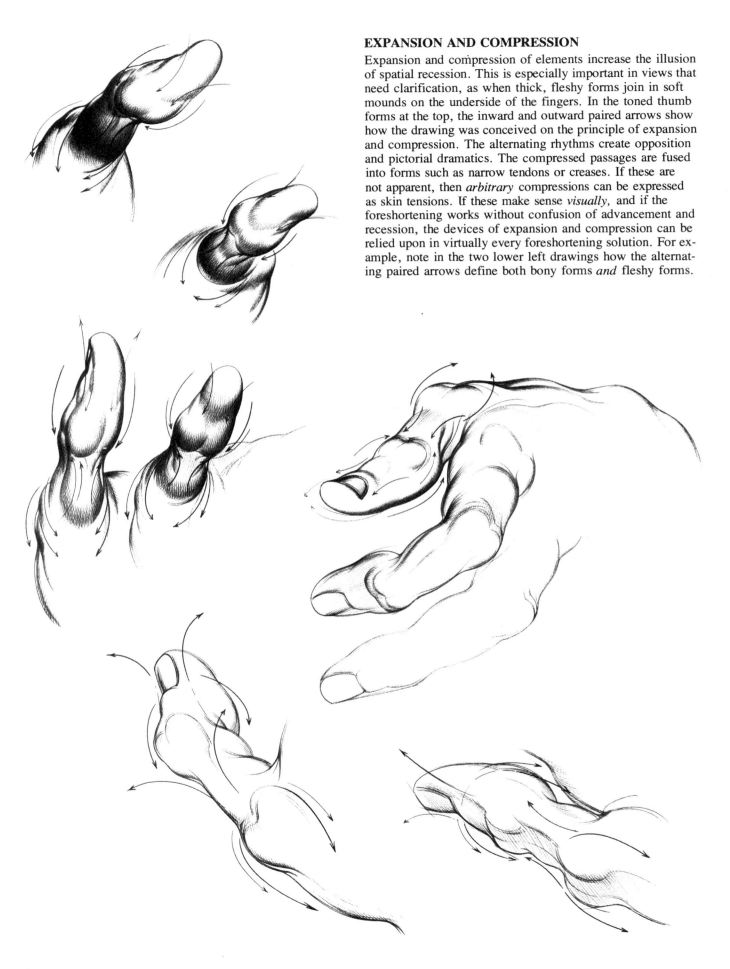

EXPANSION AND COMPRESSION

Expansion and compression of elements increase the illusion of spatial recession. This is especially important in views that need clarification, as when thick, fleshy forms join in soft mounds on the underside of the fingers. In the toned thumb forms at the top, the inward and outward paired arrows show how the drawing was conceived on the principle of expansion and compression. The alternating rhythms create opposition and pictorial dramatics. The compressed passages are fused into forms such as narrow tendons or creases. If these are not apparent, then *arbitrary* compressions can be expressed as skin tensions. If these make sense *visually,* and if the foreshortening works without confusion of advancement and recession, the devices of expansion and compression can be relied upon in virtually every foreshortening solution. For example, note in the two lower left drawings how the alternating paired arrows define both bony forms *and* fleshy forms.

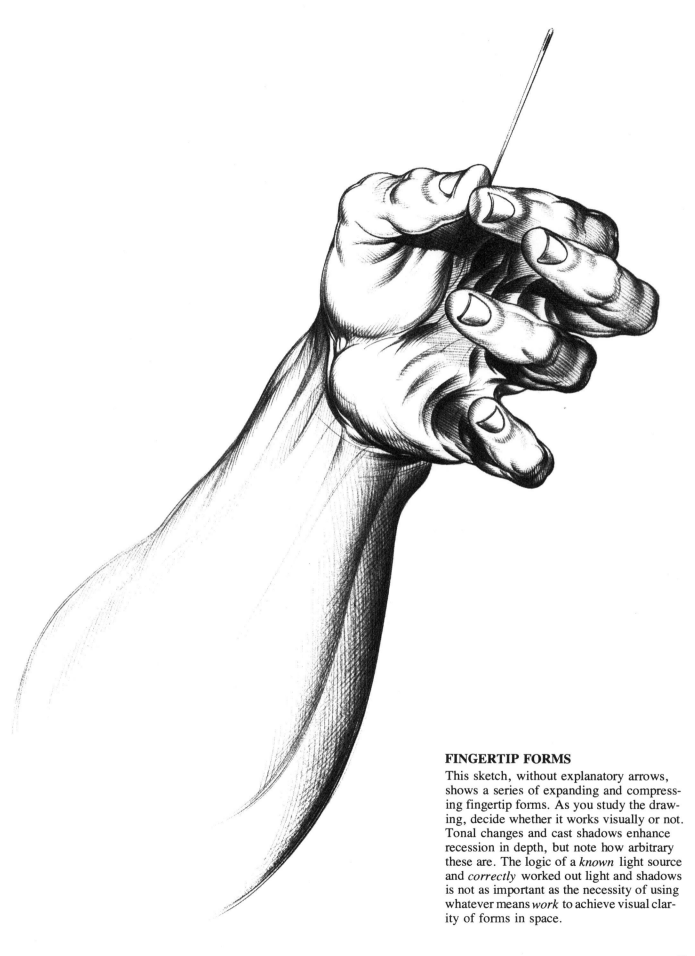

FINGERTIP FORMS

This sketch, without explanatory arrows, shows a series of expanding and compressing fingertip forms. As you study the drawing, decide whether it works visually or not. Tonal changes and cast shadows enhance recession in depth, but note how arbitrary these are. The logic of a *known* light source and *correctly* worked out light and shadows is not as important as the necessity of using whatever means *work* to achieve visual clarity of forms in space.

93

7.
INVENTING HANDS IN ACTION

The best hand actions are not necessarily copied exactly from life. Pictorial logic, design necessity, and the overall concept of the work impose their own demands. Anyone who has seen the interpretive and expressive responses of Leonardo, Michelangelo, Grünewald, or Rodin, will understand the need of the artist to create form in response to his intuitive impulses. A starting point for drawing an original and personal hand in action is to sketch, perhaps even copy, a prosaic view of one of the hand's numerous gestures. It does not have to show a remarkable attitude or even a near relationship to the expected result. It can be only a starting point from which you can develop your own personal vision.

OUTSIDE AND THUMBSIDE PALM

In the upper sketch, note how a simple movement of the index finger upward and downward can convey a sense of excitement and different shades of meaning. Changes in the position of the little finger add further emotional inflections to the movement. In the lower drawing, each finger change alters the meaning of the gesture. Study these drawings and experiment with changing emotional connotations by moving the drawings into different positions.

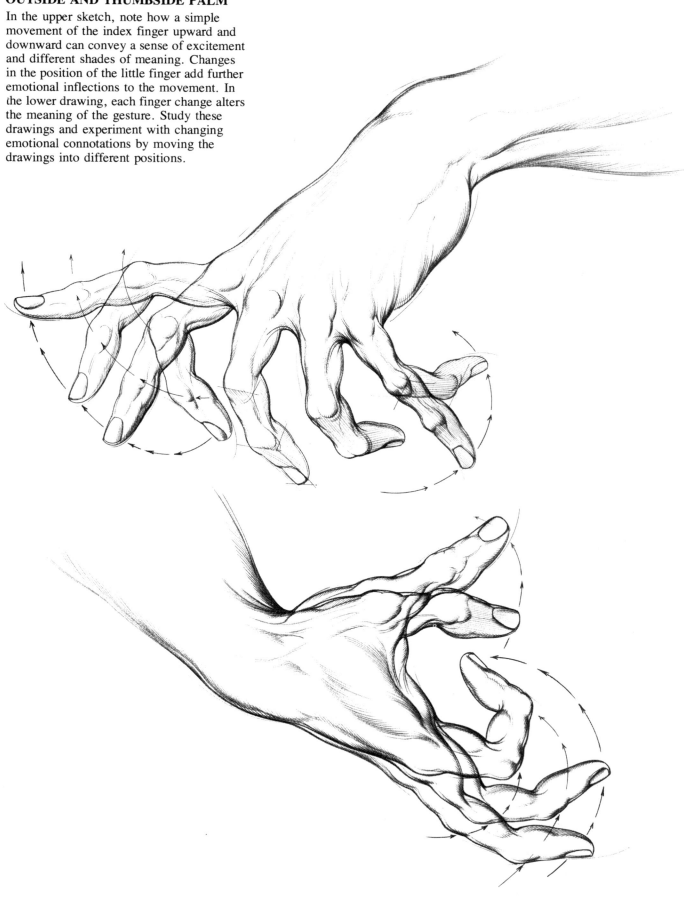

PARALLEL PROJECTION

The parallel projection method is a useful device for visualizing possible new hand views. Start with a simple sketch of some easily worked out action such as the side view with extended fingers shown here. Then set out a few horizontal track lines extending from major forms. In this case, thumb and palm muscle thickness and index and little finger lengths are being tracked. These choices are purely arbitrary and only serve to identify change of direction in form. If you need more than these in a sketch of your own, don't hesitate to put them in.

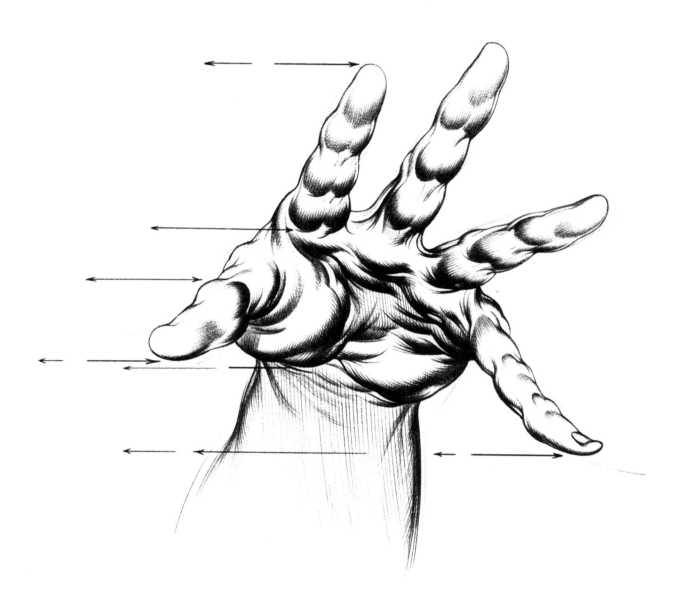

FRONTAL PARALLEL PROJECTION

With tracks laid out, sketch in a tentative deep frontal view of a hand, holding the forms to the limits of the extended lines. If they confuse the eye, sketch them in erasable colored pencils or label each line with the form's name. When you have put in your first forms, you will see a new frontal view of the hand emerge. If doubts arise, project new parallels of smaller forms. Or if certain forms inhibit you or need to be changed, then change them. The drawing is your own and it's up to you to decide what to do with it.

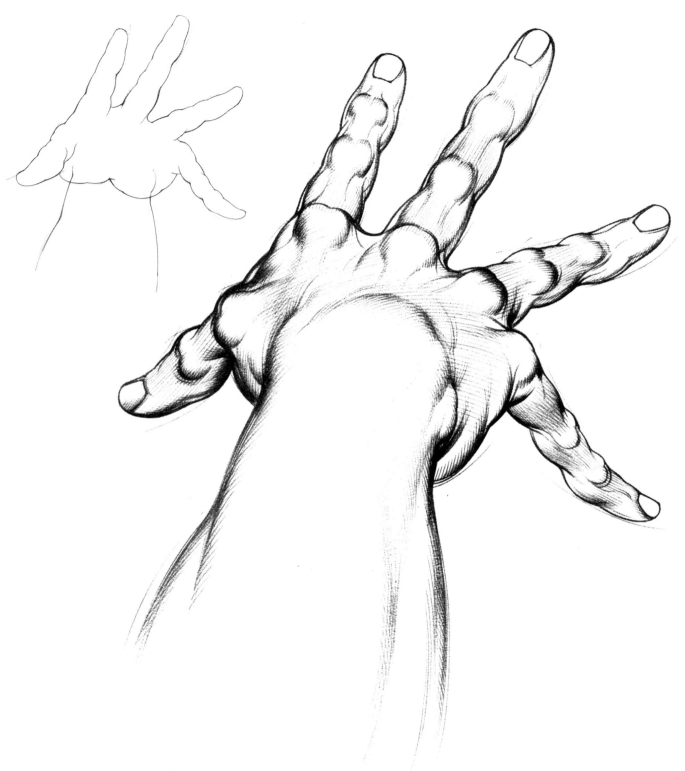

REVERSING POSITIONS

You can now do a surprising thing—you can develop the drawing of frontal foreshortening just discussed into its reversed position. First trace or copy closely the outline of the front view as shown at upper left. Note that the forearm now inserts itself into the dorsal side of the hand. This deliberately causes the eye to accept a shift in the spatial field from front to rear. Now decisively insert the contours of the palm knuckle bulges. In the drawing at right note the accented knuckle forms, the well-defined wrist curve, the ulnar head

joining the outside arm, and the line of the radial bone on the inside arm moving toward the index finger. The third step is to insert finger knuckles. These are found on the outline of the little finger and the ring finger in the sketch at left. This can be done with a simple set of arcs, with fingernails inserted. Then other fingers can easily be put in place. Tones are casually defined to show recession, and the drawing can be totally refined. At this point go back to the side view hand in the previous drawing and review this sequence.

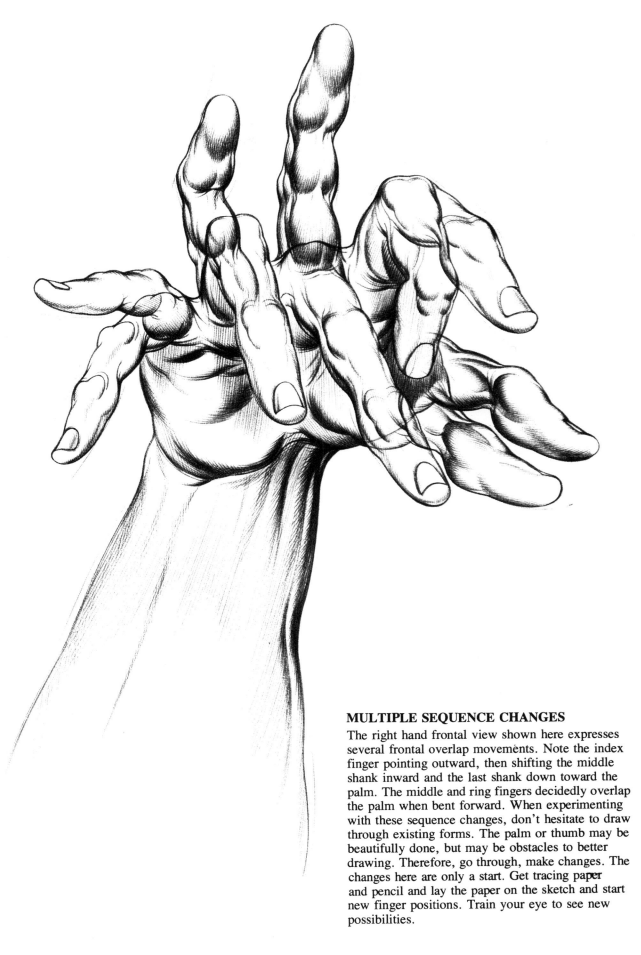

MULTIPLE SEQUENCE CHANGES

The right hand frontal view shown here expresses
several frontal overlap movements. Note the index
finger pointing outward, then shifting the middle
shank inward and the last shank down toward the
palm. The middle and ring fingers decidedly overlap
the palm when bent forward. When experimenting
with these sequence changes, don't hesitate to draw
through existing forms. The palm or thumb may be
beautifully done, but may be obstacles to better
drawing. Therefore, go through, make changes. The
changes here are only a start. Get tracing paper
and pencil and lay the paper on the sketch and start
new finger positions. Train your eye to see new
possibilities.

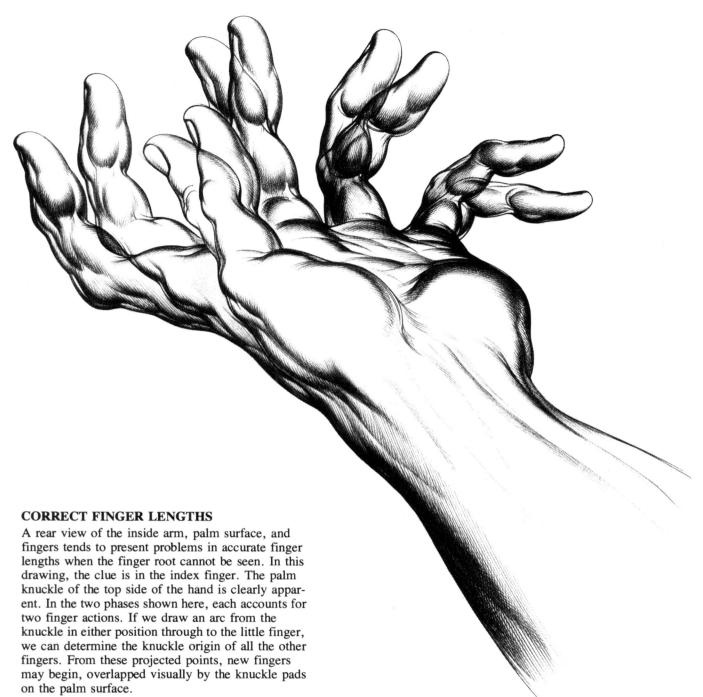

CORRECT FINGER LENGTHS

A rear view of the inside arm, palm surface, and fingers tends to present problems in accurate finger lengths when the finger root cannot be seen. In this drawing, the clue is in the index finger. The palm knuckle of the top side of the hand is clearly apparent. In the two phases shown here, each accounts for two finger actions. If we draw an arc from the knuckle in either position through to the little finger, we can determine the knuckle origin of all the other fingers. From these projected points, new fingers may begin, overlapped visually by the knuckle pads on the palm surface.

If the hand were reversed and drawn from a rear view, as done previously, finger lengths could also be deduced from the index finger and carried into the rear series. Try looking at each finger crease as if it were within an arc connected to the other fingers. Then note fingertip relationships. The forms in space can be worked carefully, section by section. The finger variations here are modest ones. More dramatic ones can be tried by using tracing paper for a new sequence. Try turning this page around and looking at the drawing from a different view. Then reorder the finger positions, exploring new positions and feeling tones.

MULTIPLE FINGERS—FRONT VIEW

This sketch shows a front multiple-finger view of the hand and the receding arm. The fingers are both extended and partially closed. It is a rather complex treatment of the problem of discovering new finger positions and examining total hand actions. The little finger is shown in three phases, the thumb in four, and the other fingers in two. Most aspects are developed transparently, which helps in making judgments about placement and measurement. It is important to train your imagination with multiple views as shown here, and it will be useful for you to come back to this chapter at a later time for further ideas and refinement.

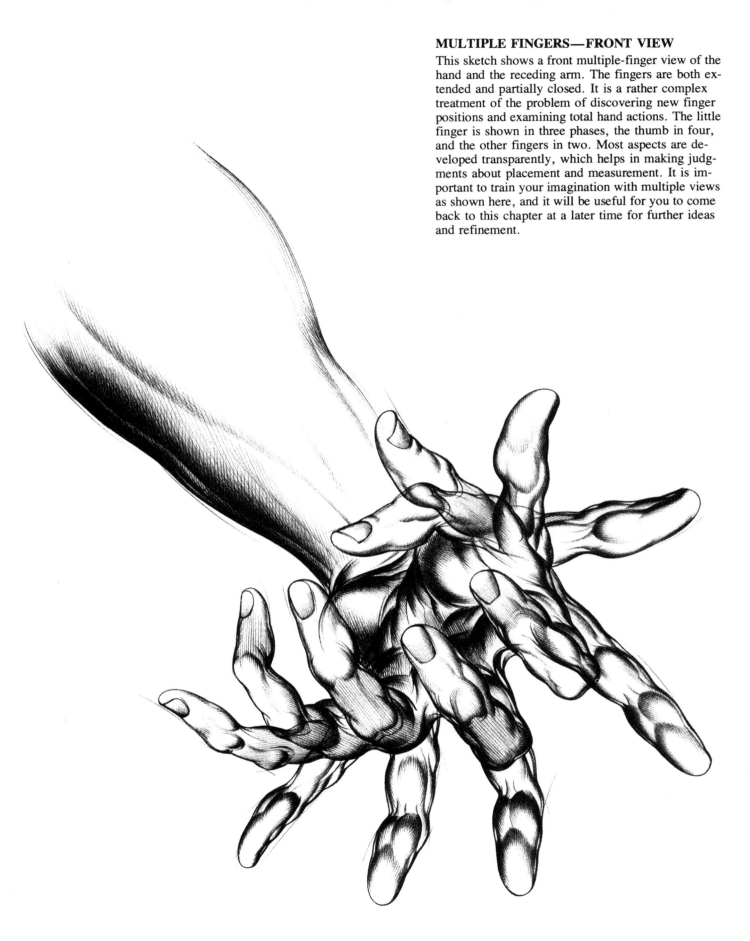

8.
THE HAND AS AN INSTRUMENT

While most anatomical structures tend to serve discrete and specialized ends, the hand, because of its plasticity, is designed to serve a wide range of needs. In a certain position, with only slight shifts in tension or direction, it can be used for very different purposes and can even express very different meanings. You will see this subtle shift in use and meaning in the drawings in this chapter. After you have explored the various ways the hand can function as a tool or an instrument as shown here, go on to other exercises of your own and explore new possibilities of the hand as an instrument.

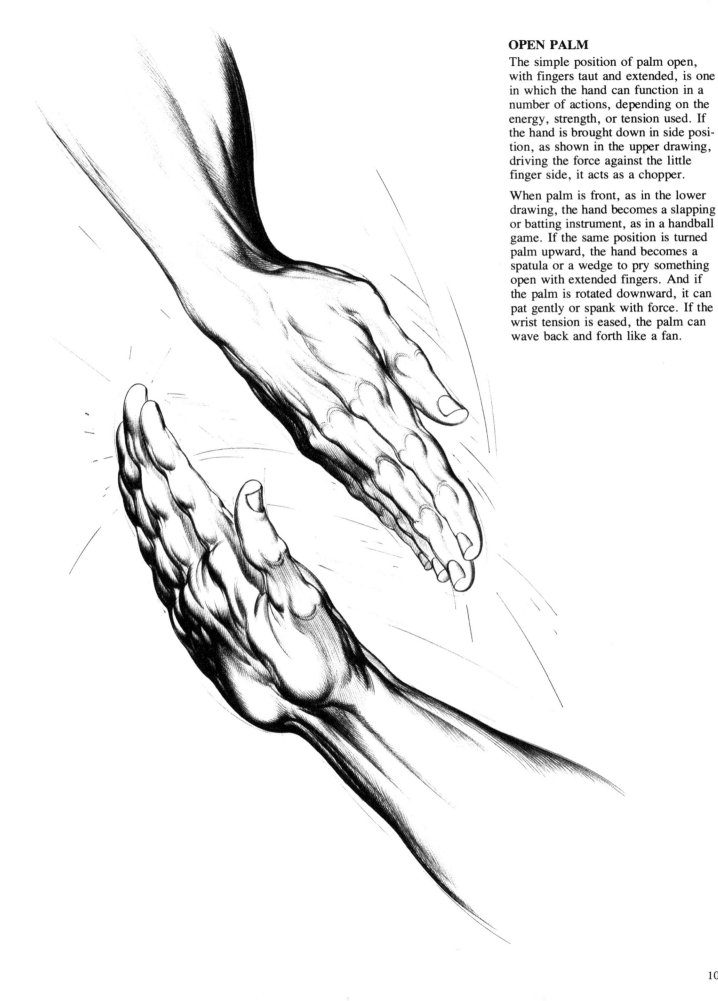

OPEN PALM

The simple position of palm open, with fingers taut and extended, is one in which the hand can function in a number of actions, depending on the energy, strength, or tension used. If the hand is brought down in side position, as shown in the upper drawing, driving the force against the little finger side, it acts as a chopper.

When palm is front, as in the lower drawing, the hand becomes a slapping or batting instrument, as in a handball game. If the same position is turned palm upward, the hand becomes a spatula or a wedge to pry something open with extended fingers. And if the palm is rotated downward, it can pat gently or spank with force. If the wrist tension is eased, the palm can wave back and forth like a fan.

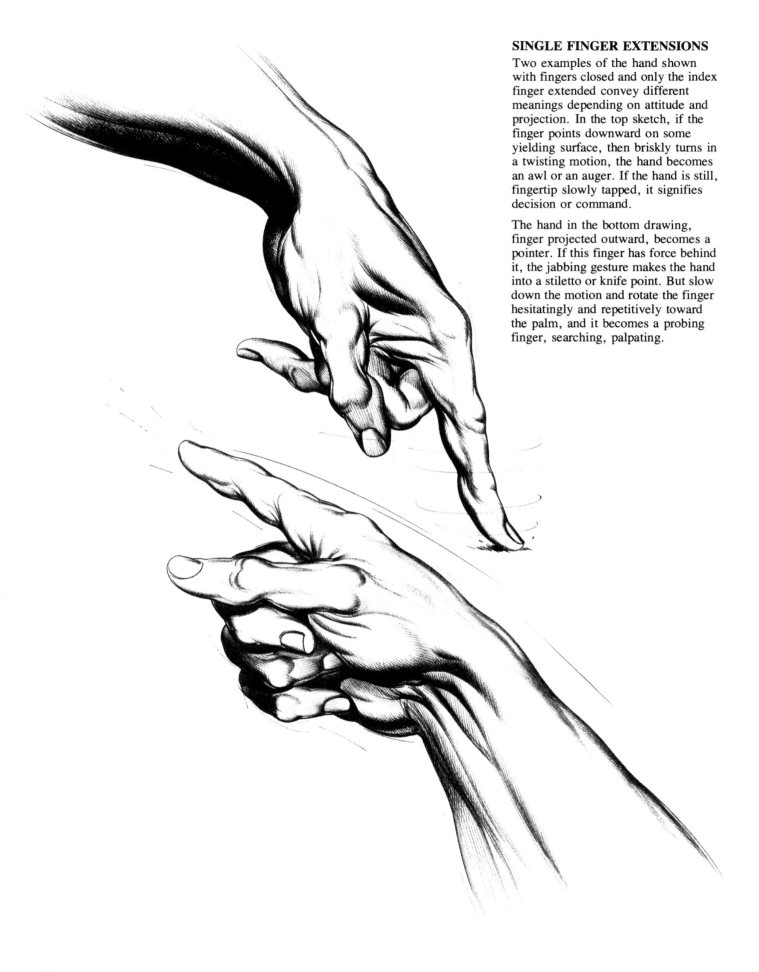

SINGLE FINGER EXTENSIONS

Two examples of the hand shown with fingers closed and only the index finger extended convey different meanings depending on attitude and projection. In the top sketch, if the finger points downward on some yielding surface, then briskly turns in a twisting motion, the hand becomes an awl or an auger. If the hand is still, fingertip slowly tapped, it signifies decision or command.

The hand in the bottom drawing, finger projected outward, becomes a pointer. If this finger has force behind it, the jabbing gesture makes the hand into a stiletto or knife point. But slow down the motion and rotate the finger hesitatingly and repetitively toward the palm, and it becomes a probing finger, searching, palpating.

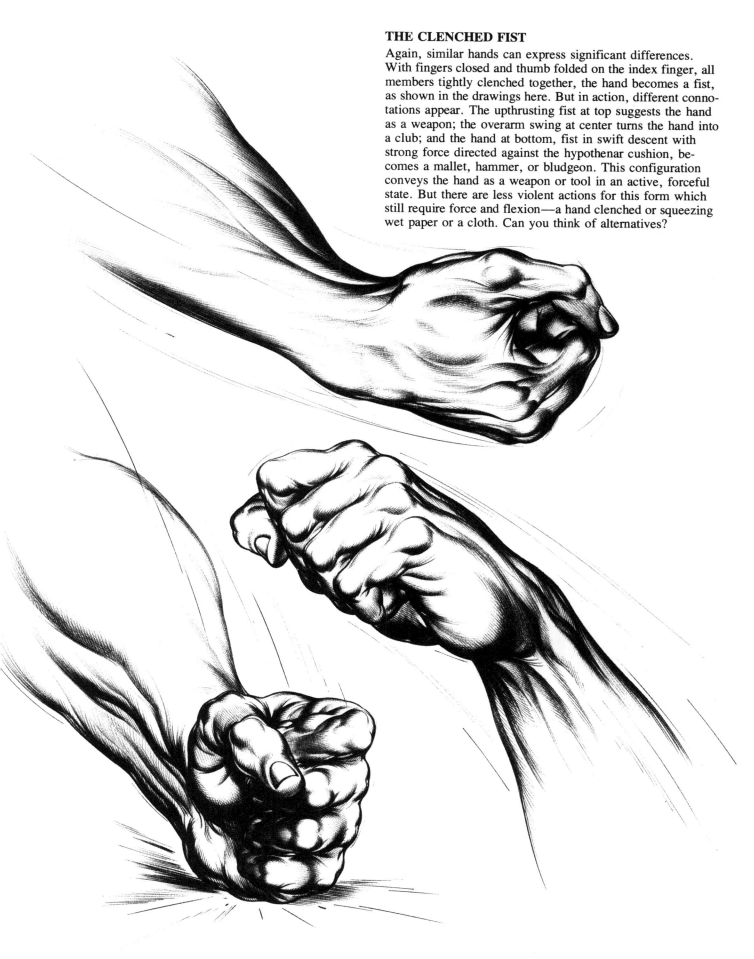

THE CLENCHED FIST

Again, similar hands can express significant differences. With fingers closed and thumb folded on the index finger, all members tightly clenched together, the hand becomes a fist, as shown in the drawings here. But in action, different connotations appear. The upthrusting fist at top suggests the hand as a weapon; the overarm swing at center turns the hand into a club; and the hand at bottom, fist in swift descent with strong force directed against the hypothenar cushion, becomes a mallet, hammer, or bludgeon. This configuration conveys the hand as a weapon or tool in an active, forceful state. But there are less violent actions for this form which still require force and flexion—a hand clenched or squeezing wet paper or a cloth. Can you think of alternatives?

THE HAND AS A CLAW

With fingers open, spread, and half-flexed like claws, the versatile hand takes on the function of a rake or scraper, as in the upper sketch, or a comb or grappling hook, as shown below. Note the cramped look of the upper hand, obviously taut for dealing with stubborn grit or gravel. The somewhat open fingers below are more appropriate for running gently through the hair.

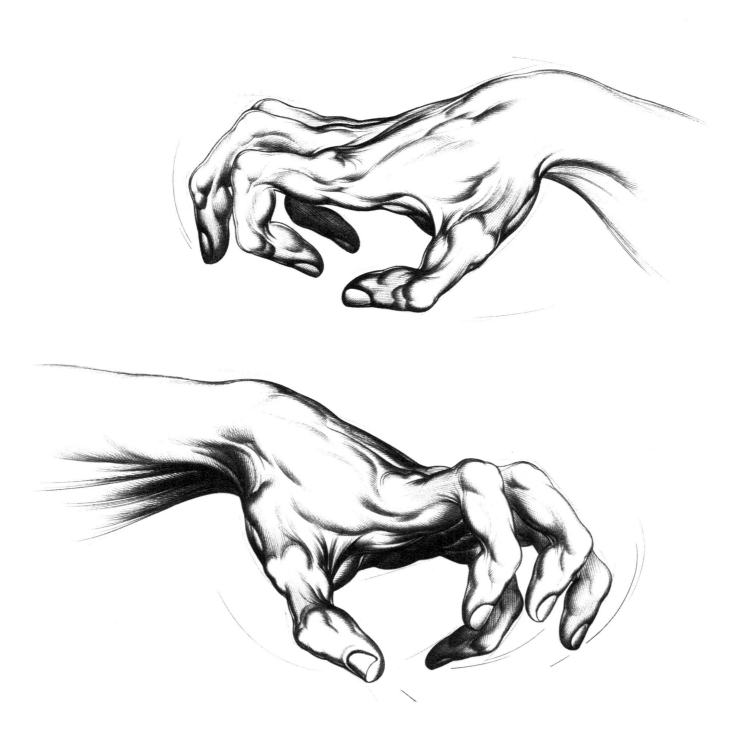

106

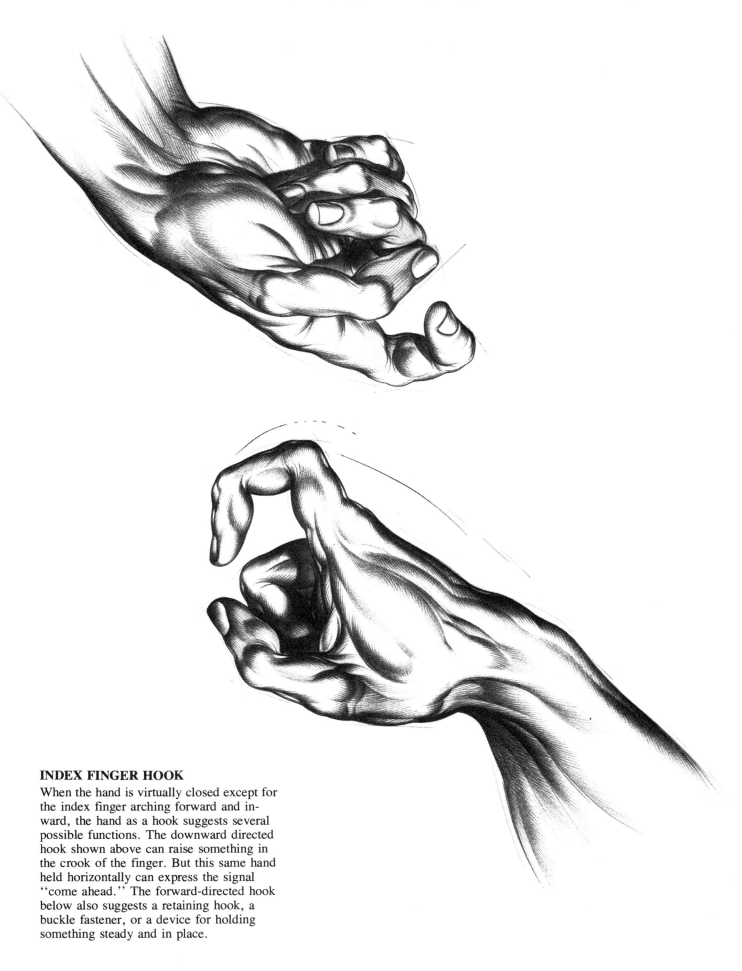

INDEX FINGER HOOK

When the hand is virtually closed except for
the index finger arching forward and in-
ward, the hand as a hook suggests several
possible functions. The downward directed
hook shown above can raise something in
the crook of the finger. But this same hand
held horizontally can express the signal
''come ahead.'' The forward-directed hook
below also suggests a retaining hook, a
buckle fastener, or a device for holding
something steady and in place.

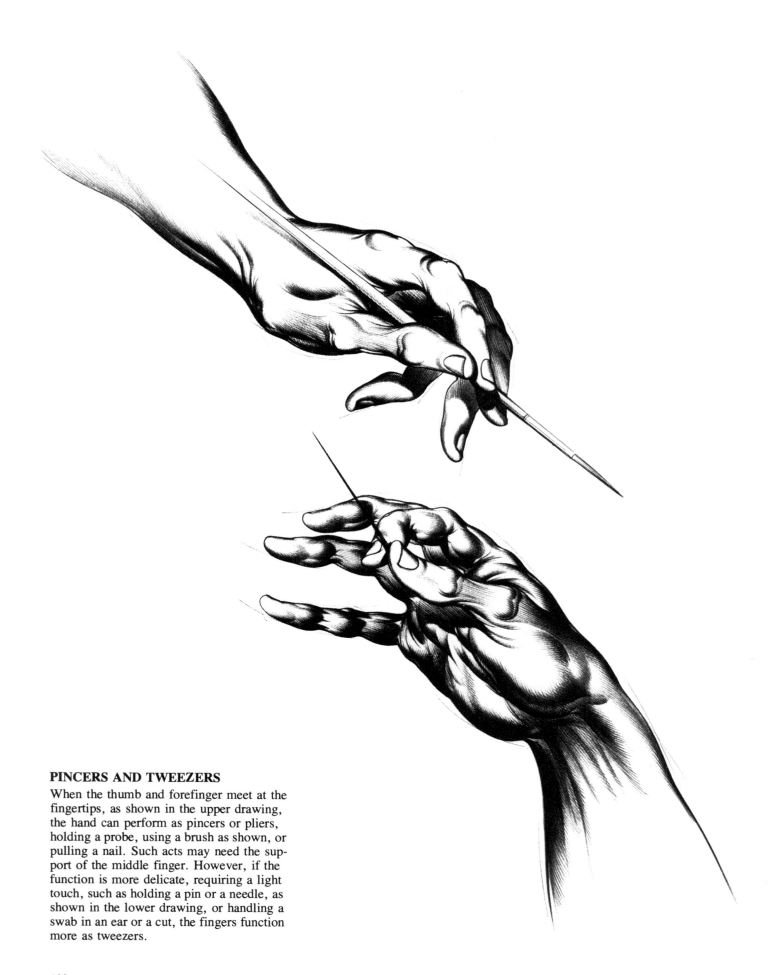

PINCERS AND TWEEZERS

When the thumb and forefinger meet at the
fingertips, as shown in the upper drawing,
the hand can perform as pincers or pliers,
holding a probe, using a brush as shown, or
pulling a nail. Such acts may need the sup-
port of the middle finger. However, if the
function is more delicate, requiring a light
touch, such as holding a pin or a needle, as
shown in the lower drawing, or handling a
swab in an ear or a cut, the fingers function
more as tweezers.

108

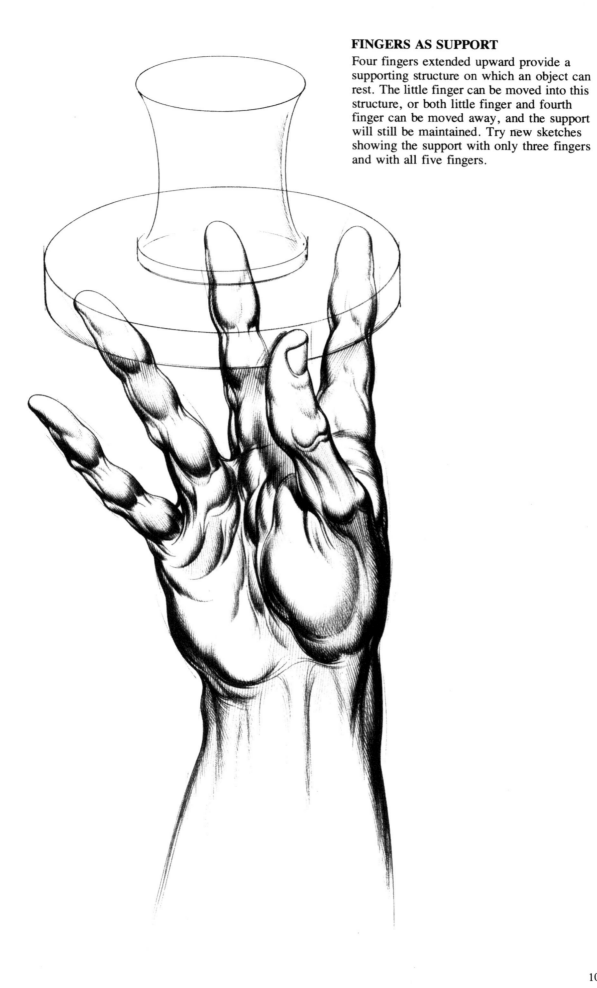

FINGERS AS SUPPORT

Four fingers extended upward provide a supporting structure on which an object can rest. The little finger can be moved into this structure, or both little finger and fourth finger can be moved away, and the support will still be maintained. Try new sketches showing the support with only three fingers and with all five fingers.

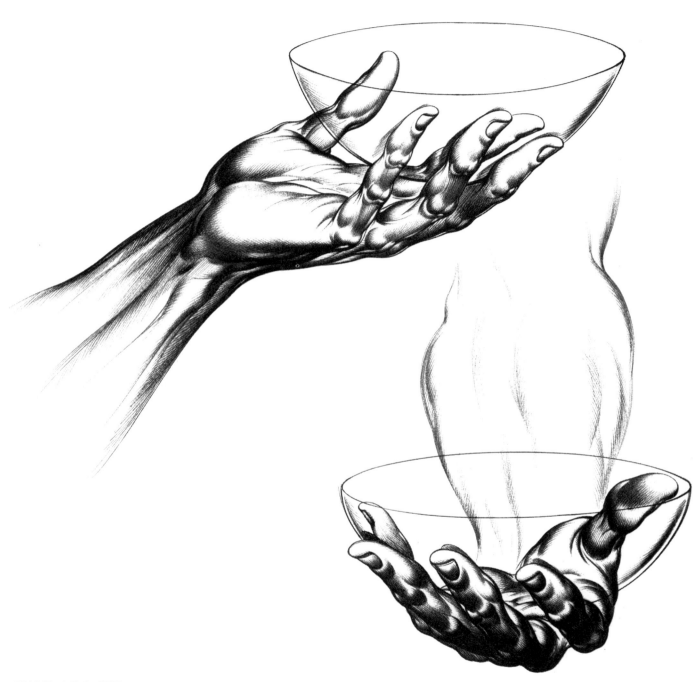

HAND AS A CUP

The hand can also act as a cup or a bowl, with fingers extended in a circle holding something, as shown from the side view in the upper drawing and from front view in the lower. This is a remarkable change from the hand as a tool, a club, a cleaver. Here the hand must respond to an object outside itself, the object actually governing the contour the hand takes on.

HANDS AS A TRESTLE

When the arm is projected forward against the hand, which is firmly placed with fingertips braced on a table or the ground, with body weight imposed against it, the stiff fingers will be spread in a wide ellipse directed outward from the line of the arm. In this position the hand will have the effect of a supporting trestle structure. The fingertips will tend to flatten and push forward from the taut, angularly elevated hand. Note the almost inverted stress of the little finger, which seems to be near buckling under the weight put upon it.

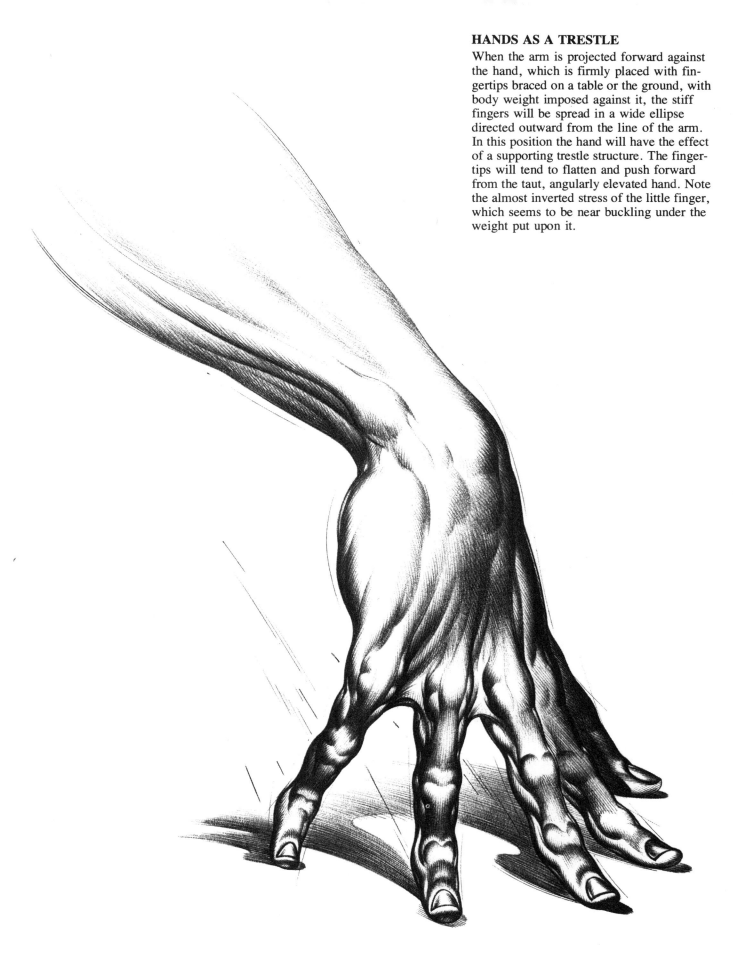

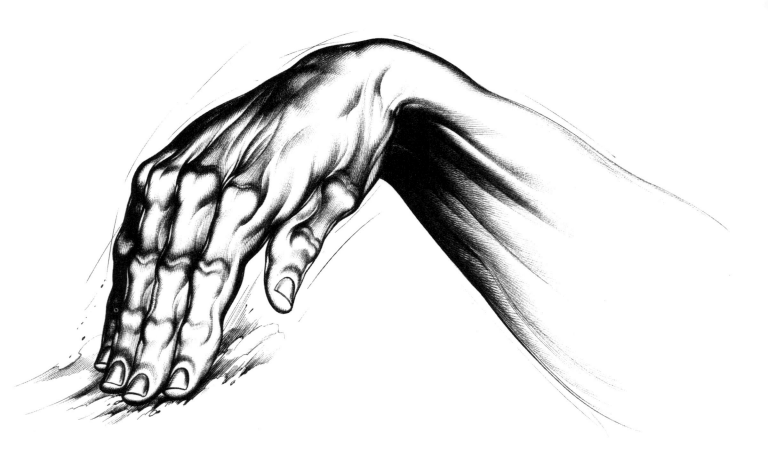

HAND AS A DIGGING TOOL

As the entire hand projects down at a sharp angle from the thrust-out arm, close-set fingers projecting down from the palm knuckles, the hand becomes a digging tool. The form here is a spatulate, flat wedge discussed at the beginning of this chapter. If the hand were to act as a spade or shovel, both the direction and the action of the hand would be reversed.

HANDS AS A BASKET

To draw hands in the position of a basket or a sling requires exacting control in finger placement. Alternating elements dovetail as bony knuckles interlock with the compressed and cushioned finger shanks. This position creates a rhythmic series of undulations, with its carefully articulated rod and ball forms. Note the fingernails gradually turning toward the underside of the basket, becoming less and less round down to the disappearing fingers. Attention to these minimal forms is as important as to the curves and shadows of the large thumbs.

9.
COMMUNICATION AND GESTURE

The hand not only functions as a tool, it also communicates meaning and experience, supporting facial and bodily expression. These meanings often go beyond the level of verbal expression and are meant to be picked up by the acute swiftness of the eye. In this chapter we shall look at some typical and well-known gestures, and study how only the gestures made by the hand could communicate the meaning intended. Some gestures discussed here are cultural and cross-cultural, still carrying close to their original historical meanings such as the concept of number, the concept of leadership and deity, and both ancient and modern sign language.

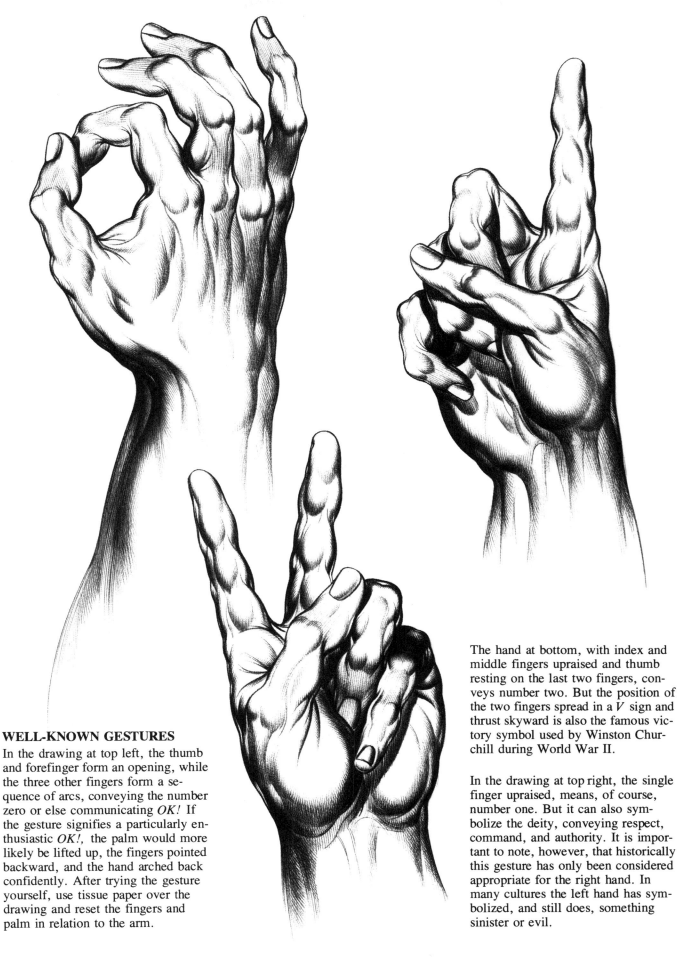

WELL-KNOWN GESTURES

In the drawing at top left, the thumb and forefinger form an opening, while the three other fingers form a sequence of arcs, conveying the number zero or else communicating *OK!* If the gesture signifies a particularly enthusiastic *OK!,* the palm would more likely be lifted up, the fingers pointed backward, and the hand arched back confidently. After trying the gesture yourself, use tissue paper over the drawing and reset the fingers and palm in relation to the arm.

The hand at bottom, with index and middle fingers upraised and thumb resting on the last two fingers, conveys number two. But the position of the two fingers spread in a *V* sign and thrust skyward is also the famous victory symbol used by Winston Churchill during World War II.

In the drawing at top right, the single finger upraised, means, of course, number one. But it can also symbolize the deity, conveying respect, command, and authority. It is important to note, however, that historically this gesture has only been considered appropriate for the right hand. In many cultures the left hand has symbolized, and still does, something sinister or evil.

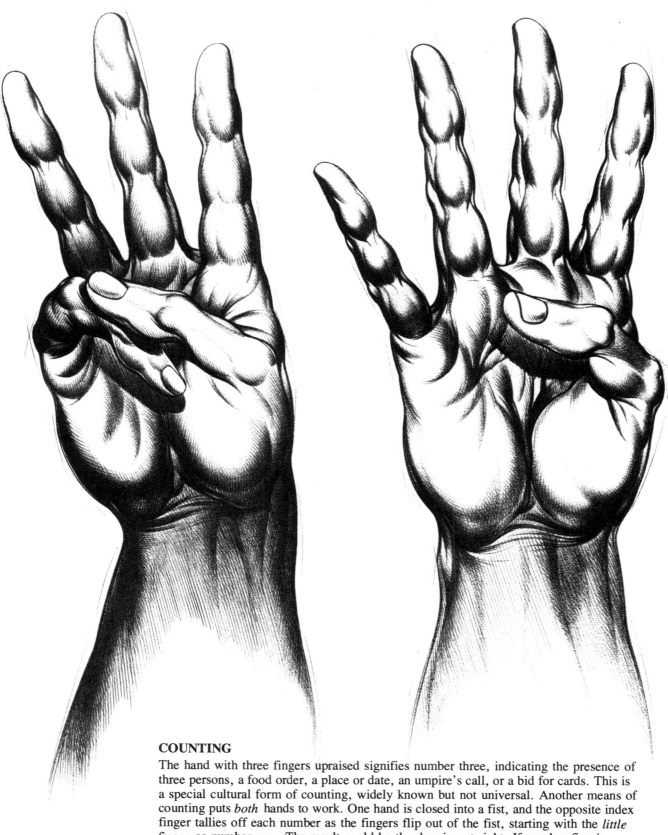

COUNTING

The hand with three fingers upraised signifies number three, indicating the presence of three persons, a food order, a place or date, an umpire's call, or a bid for cards. This is a special cultural form of counting, widely known but not universal. Another means of counting puts *both* hands to work. One hand is closed into a fist, and the opposite index finger tallies off each number as the fingers flip out of the fist, starting with the *little finger* as number *one*. The result could be the drawing at right. If number five is required, the thumb would be lifted out in open position.

The hand at left with three fingers out also carries religious connotations, signifying the powers of the divine, three in one. But in formal, orthodox Catholic usage, the finger order shown here is not appropriate. The fingers must be the *first* three, starting with the thumb, not the middle three.

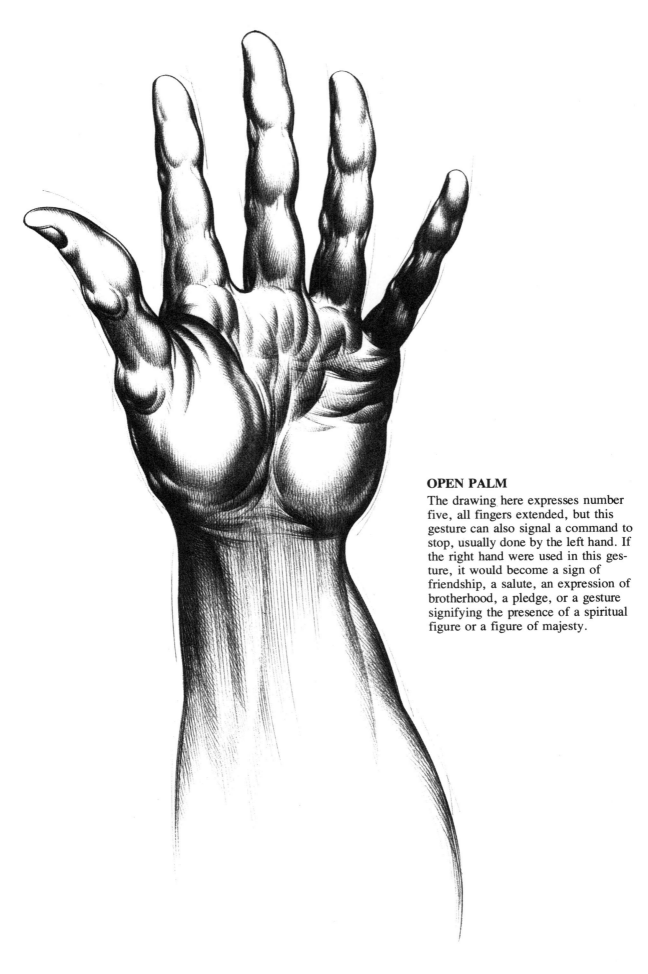

OPEN PALM

The drawing here expresses number five, all fingers extended, but this gesture can also signal a command to stop, usually done by the left hand. If the right hand were used in this gesture, it would become a sign of friendship, a salute, an expression of brotherhood, a pledge, or a gesture signifying the presence of a spiritual figure or a figure of majesty.

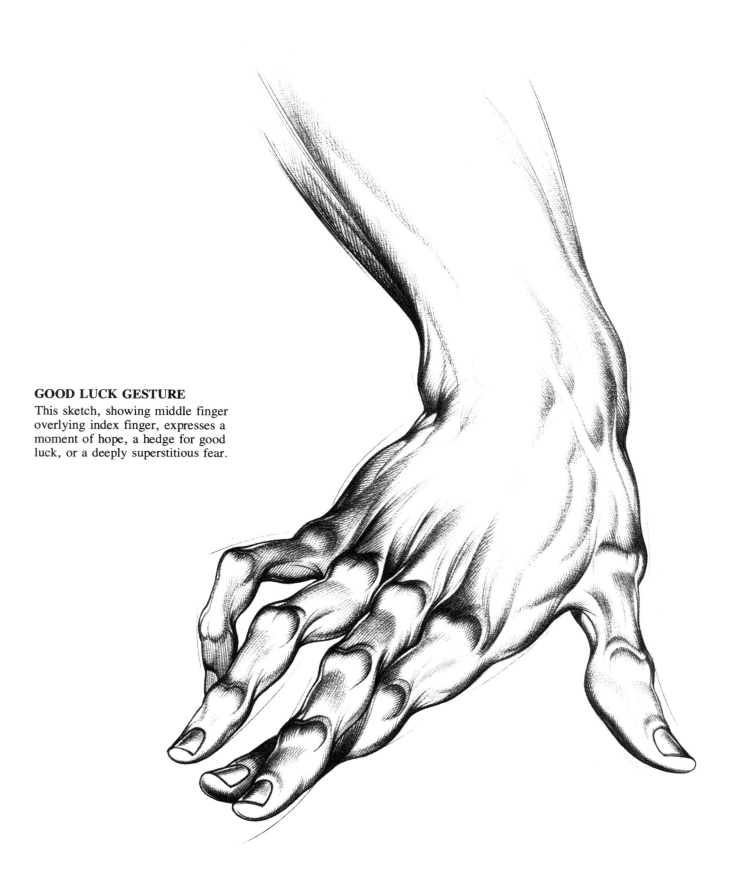

GOOD LUCK GESTURE
This sketch, showing middle finger overlying index finger, expresses a moment of hope, a hedge for good luck, or a deeply superstitious fear.

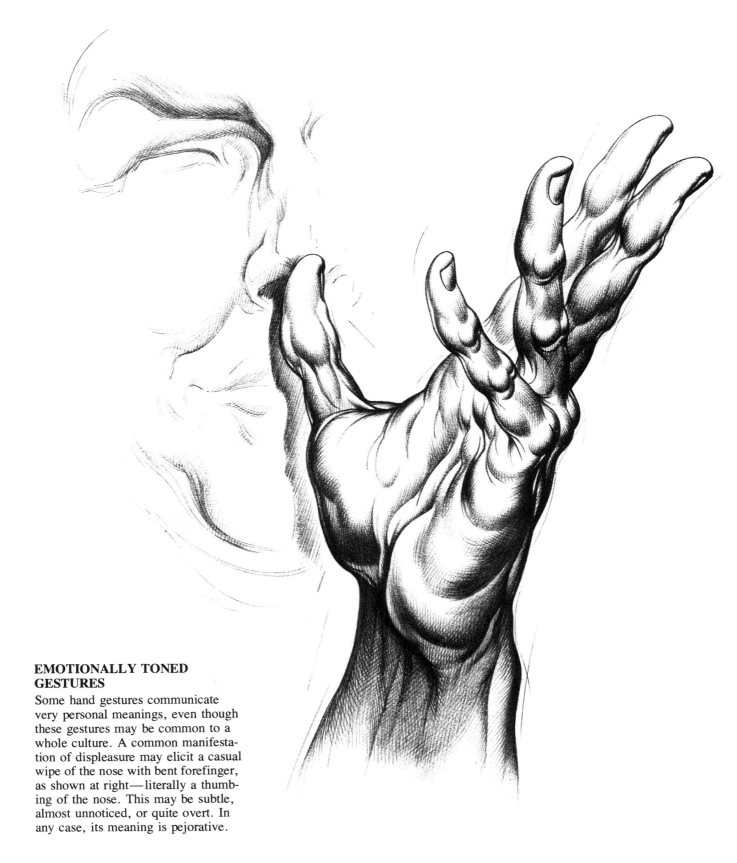

EMOTIONALLY TONED GESTURES

Some hand gestures communicate very personal meanings, even though these gestures may be common to a whole culture. A common manifestation of displeasure may elicit a casual wipe of the nose with bent forefinger, as shown at right—literally a thumbing of the nose. This may be subtle, almost unnoticed, or quite overt. In any case, its meaning is pejorative.

HISTORICAL MEANINGS—
SUCCESS OR FAILURE

The drawings here suggest the yes or
no, life or death decisions of an ear-
lier Roman society. While these sig-
nals no longer carry the same political
or moral connotations, they still sug-
gest some of the meanings. If the
thumb is thrust vigorously into the
air, it suggests survival, victory, life.
If it is thrust downward, it suggests
extinction, failure, death. In the
Roman world, the thumb was called
the Thumb of Hercules, suggesting
virility and vitality. In our time we
see the closed fist beating the chest as
the Roman equivalent of affirmation,
strength, and success.

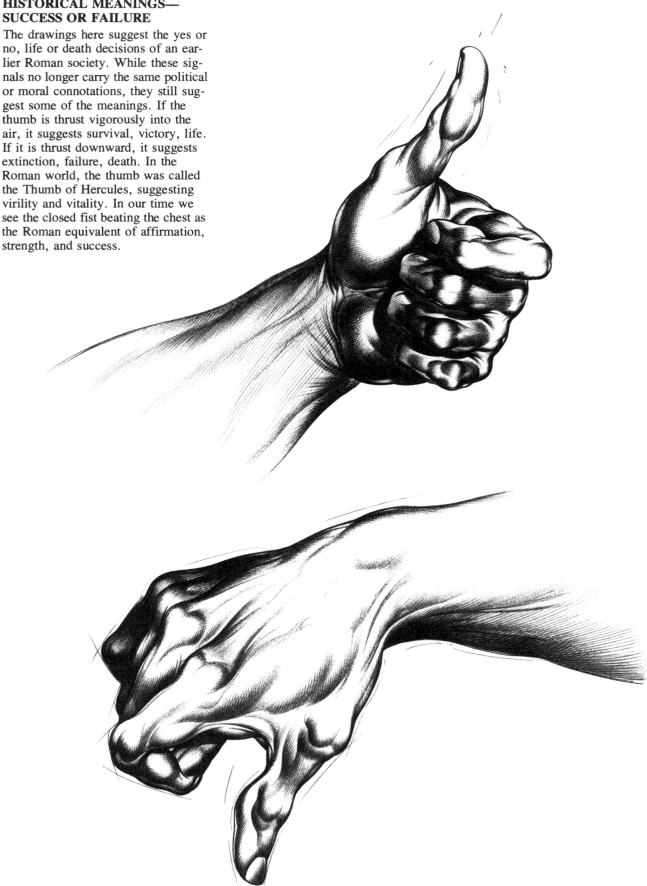

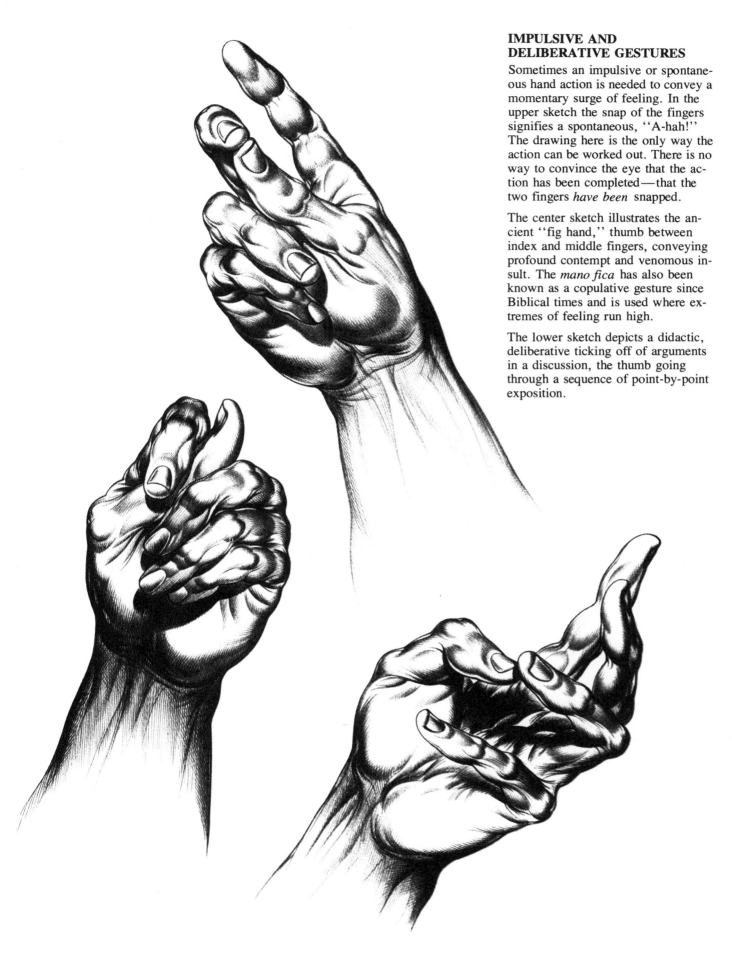

IMPULSIVE AND DELIBERATIVE GESTURES

Sometimes an impulsive or spontaneous hand action is needed to convey a momentary surge of feeling. In the upper sketch the snap of the fingers signifies a spontaneous, "A-hah!" The drawing here is the only way the action can be worked out. There is no way to convince the eye that the action has been completed—that the two fingers *have been* snapped.

The center sketch illustrates the ancient "fig hand," thumb between index and middle fingers, conveying profound contempt and venomous insult. The *mano fica* has also been known as a copulative gesture since Biblical times and is used where extremes of feeling run high.

The lower sketch depicts a didactic, deliberative ticking off of arguments in a discussion, the thumb going through a sequence of point-by-point exposition.

10.
AGING

The hand changes radically from infancy to old age, not only in size, proportion, and structure, but also in skin texture, tissue structure, and surface characteristics such as hair density, pigmentation, and size, shape, and texture of fingernails. Its dexterity and capabilities, its responsiveness, its range of gestures, and the subtlety of its emotional communications also change. Studies of the developmental and aging aspects of the hand have sometimes been overlooked in anatomical works. This chapter will trace the development of the hand from infancy to old age.

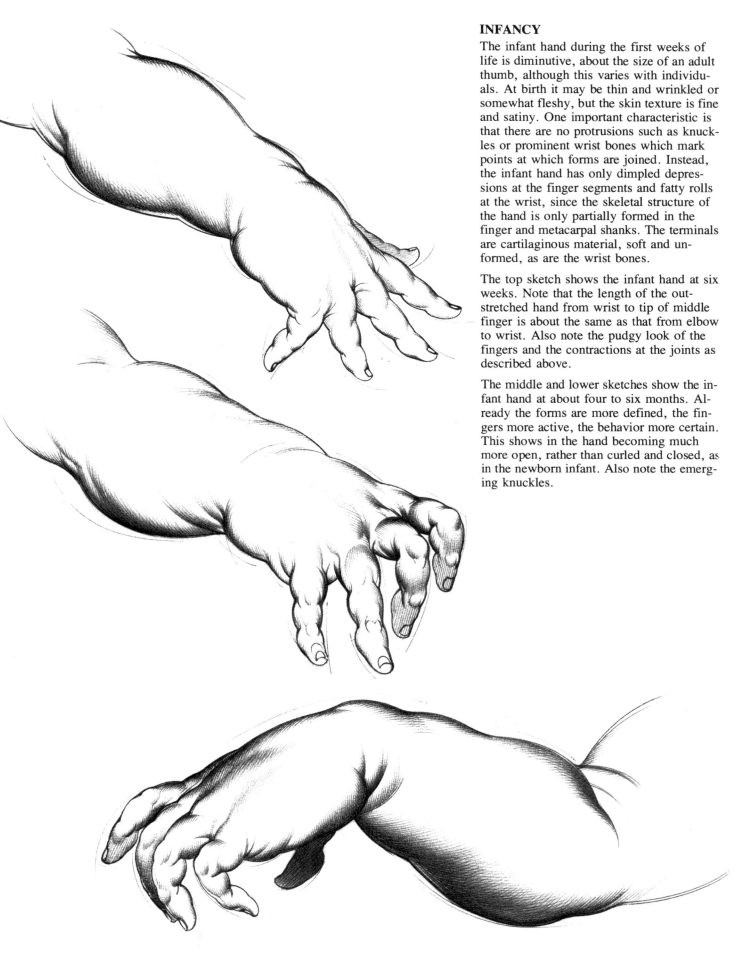

INFANCY

The infant hand during the first weeks of life is diminutive, about the size of an adult thumb, although this varies with individuals. At birth it may be thin and wrinkled or somewhat fleshy, but the skin texture is fine and satiny. One important characteristic is that there are no protrusions such as knuckles or prominent wrist bones which mark points at which forms are joined. Instead, the infant hand has only dimpled depressions at the finger segments and fatty rolls at the wrist, since the skeletal structure of the hand is only partially formed in the finger and metacarpal shanks. The terminals are cartilaginous material, soft and unformed, as are the wrist bones.

The top sketch shows the infant hand at six weeks. Note that the length of the outstretched hand from wrist to tip of middle finger is about the same as that from elbow to wrist. Also note the pudgy look of the fingers and the contractions at the joints as described above.

The middle and lower sketches show the infant hand at about four to six months. Already the forms are more defined, the fingers more active, the behavior more certain. This shows in the hand becoming much more open, rather than curled and closed, as in the newborn infant. Also note the emerging knuckles.

INFANCY TO ONE YEAR

The general character of the baby's
hand does not change substantially
during the first year. The forms are
still squat, square, and fleshy, with
little strong delineation between
forms. Both dorsal and palmar sides
of the hand are palpable and chubby,
with dainty shell-like fingernails. Yet
the hands of a one-year-old child have
begun to move with more certainty—
probing, seeking, feeling. The hand is
the first form to project into and ex-
plore an unfamiliar world.

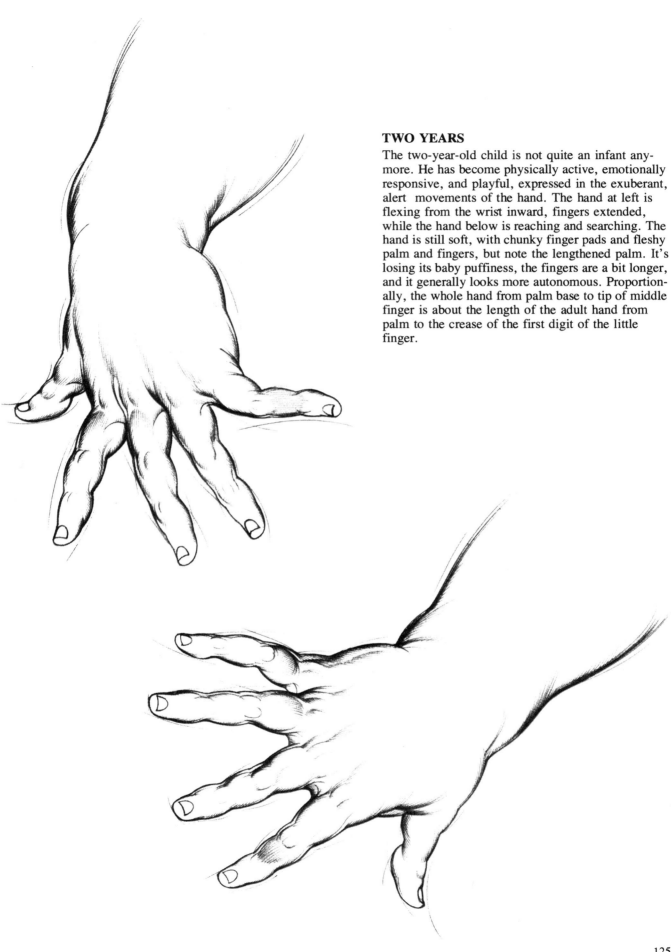

TWO YEARS

The two-year-old child is not quite an infant any-more. He has become physically active, emotionally responsive, and playful, expressed in the exuberant, alert movements of the hand. The hand at left is flexing from the wrist inward, fingers extended, while the hand below is reaching and searching. The hand is still soft, with chunky finger pads and fleshy palm and fingers, but note the lengthened palm. It's losing its baby puffiness, the fingers are a bit longer, and it generally looks more autonomous. Proportionally, the whole hand from palm base to tip of middle finger is about the length of the adult hand from palm to the crease of the first digit of the little finger.

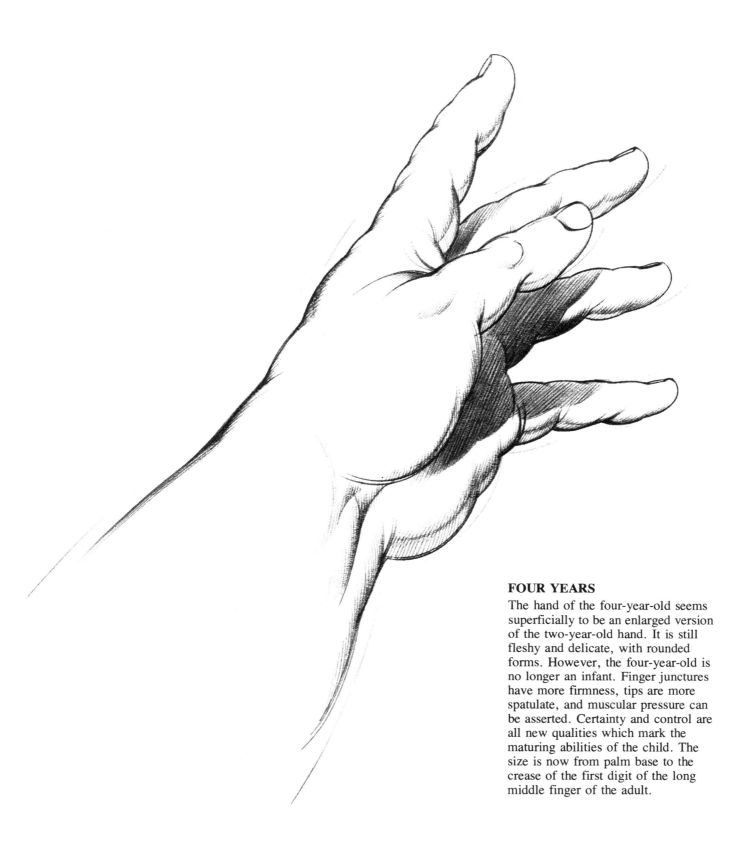

FOUR YEARS

The hand of the four-year-old seems superficially to be an enlarged version of the two-year-old hand. It is still fleshy and delicate, with rounded forms. However, the four-year-old is no longer an infant. Finger junctures have more firmness, tips are more spatulate, and muscular pressure can be asserted. Certainty and control are all new qualities which mark the maturing abilities of the child. The size is now from palm base to the crease of the first digit of the long middle finger of the adult.

SEVEN TO EIGHT YEARS

The hand of the seven- to eight-year-old child is characterized by a leaner aspect throughout. The stubby, chunky look is gone. The fingers are longer; the skin is still smooth, but tougher; the tips are flatter; and the nails are stronger and more durable. Knuckles no longer sink in dimpled recessions, but are clearly evident. The wrist and arm shank are taut and competent and have lost their baby softness. The hand is active and full of fantasy, releasing feeling and exhibiting heightened finger dexterity. The child at this stage will reveal a wide sphere of physical activity, reveling in acts that are vivid, imaginative, and pragmatic. Compared to the adult hand, this child's hand will measure from the heel of the adult palm to the second digit of the index finger.

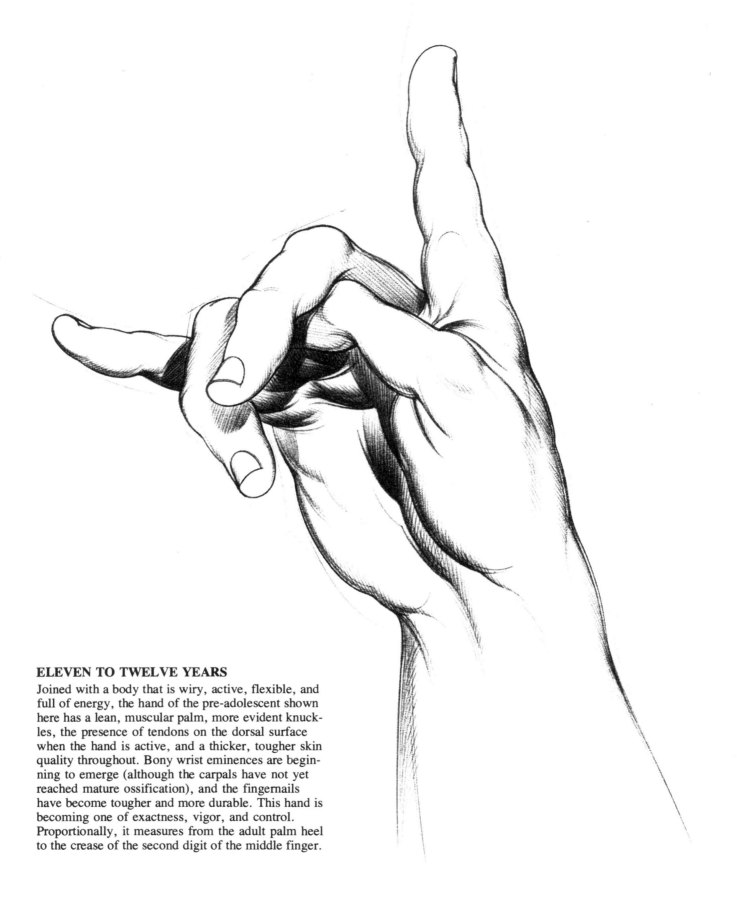

ELEVEN TO TWELVE YEARS

Joined with a body that is wiry, active, flexible, and full of energy, the hand of the pre-adolescent shown here has a lean, muscular palm, more evident knuckles, the presence of tendons on the dorsal surface when the hand is active, and a thicker, tougher skin quality throughout. Bony wrist eminences are beginning to emerge (although the carpals have not yet reached mature ossification), and the fingernails have become tougher and more durable. This hand is becoming one of exactness, vigor, and control. Proportionally, it measures from the adult palm heel to the crease of the second digit of the middle finger.

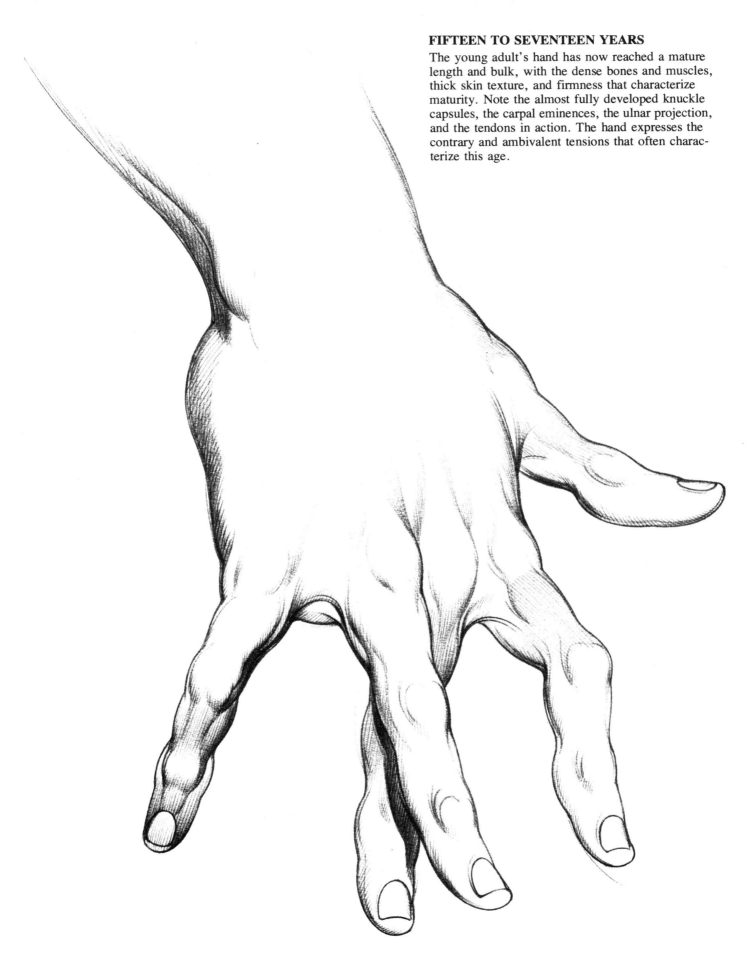

FIFTEEN TO SEVENTEEN YEARS

The young adult's hand has now reached a mature length and bulk, with the dense bones and muscles, thick skin texture, and firmness that characterize maturity. Note the almost fully developed knuckle capsules, the carpal eminences, the ulnar projection, and the tendons in action. The hand expresses the contrary and ambivalent tensions that often characterize this age.

TWENTY TO TWENTY-FIVE YEARS

The most striking changes that occur in the mature hand after
twenty years of age are in behavior. A more purposeful,
well-coordinated behavior emerges, as shown in the assertive
energies of the hand here. The mature hand you draw may be
intellectual or physical, depending on its expression, but it is
important that it be thematically whole and coordinated in its
parts.

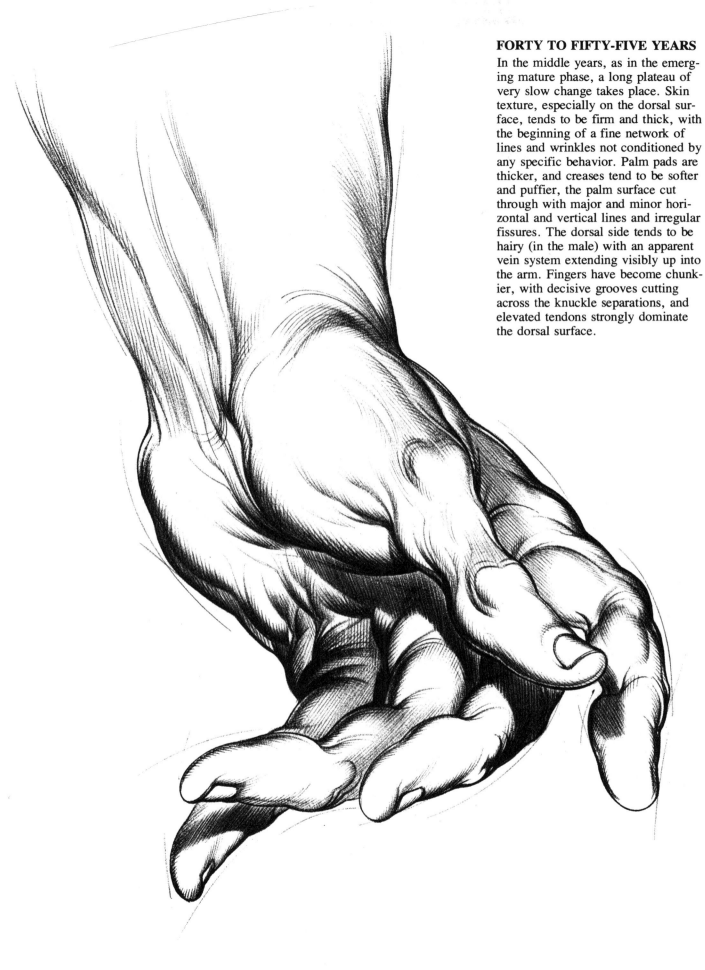

FORTY TO FIFTY-FIVE YEARS

In the middle years, as in the emerging mature phase, a long plateau of very slow change takes place. Skin texture, especially on the dorsal surface, tends to be firm and thick, with the beginning of a fine network of lines and wrinkles not conditioned by any specific behavior. Palm pads are thicker, and creases tend to be softer and puffier, the palm surface cut through with major and minor horizontal and vertical lines and irregular fissures. The dorsal side tends to be hairy (in the male) with an apparent vein system extending visibly up into the arm. Fingers have become chunkier, with decisive grooves cutting across the knuckle separations, and elevated tendons strongly dominate the dorsal surface.

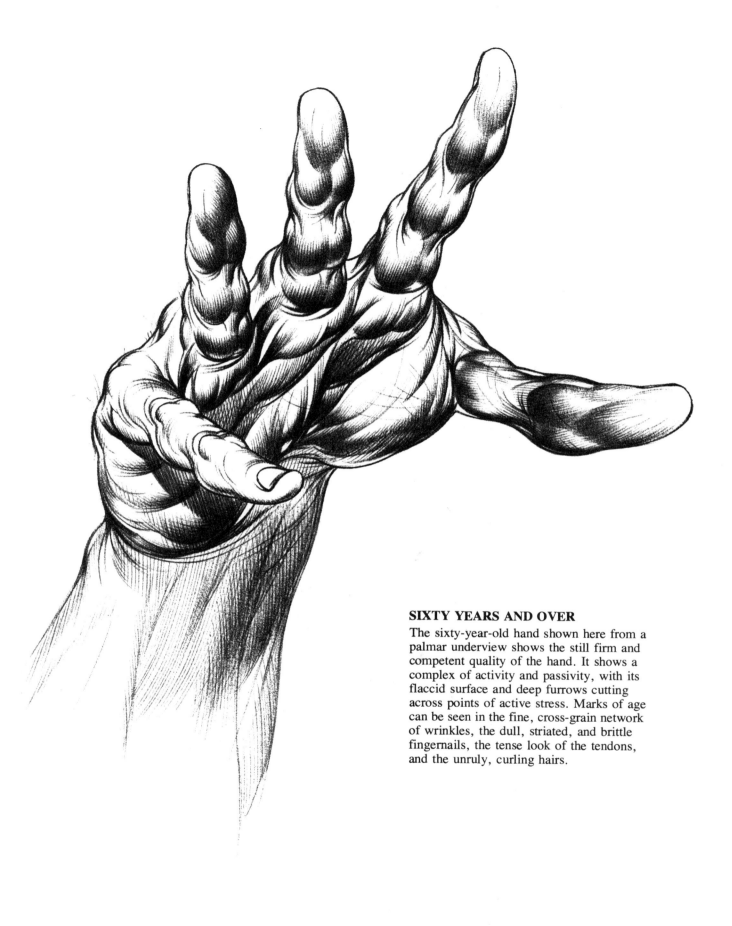

SIXTY YEARS AND OVER

The sixty-year-old hand shown here from a palmar underview shows the still firm and competent quality of the hand. It shows a complex of activity and passivity, with its flaccid surface and deep furrows cutting across points of active stress. Marks of age can be seen in the fine, cross-grain network of wrinkles, the dull, striated, and brittle fingernails, the tense look of the tendons, and the unruly, curling hairs.

SEVENTY YEARS AND OVER

The dominant characteristic of the hands in advanced age is a transparency of all top surfaces. Forms tend to contract, but the overall look is one of elongation because of the emerging skeletal structure from underneath. The musculature has become wasted and infirm, the skin thin, fine, and fragile, with veins prominent. Random wrinkling, thickened muscle creases, and enlarged joints also add to the typical aged look, along with the slight tremor suggesting loss of alertness and activity. Higher, the carpus with its boniness and the thin shanks of the arm bones all suggest advancing age.

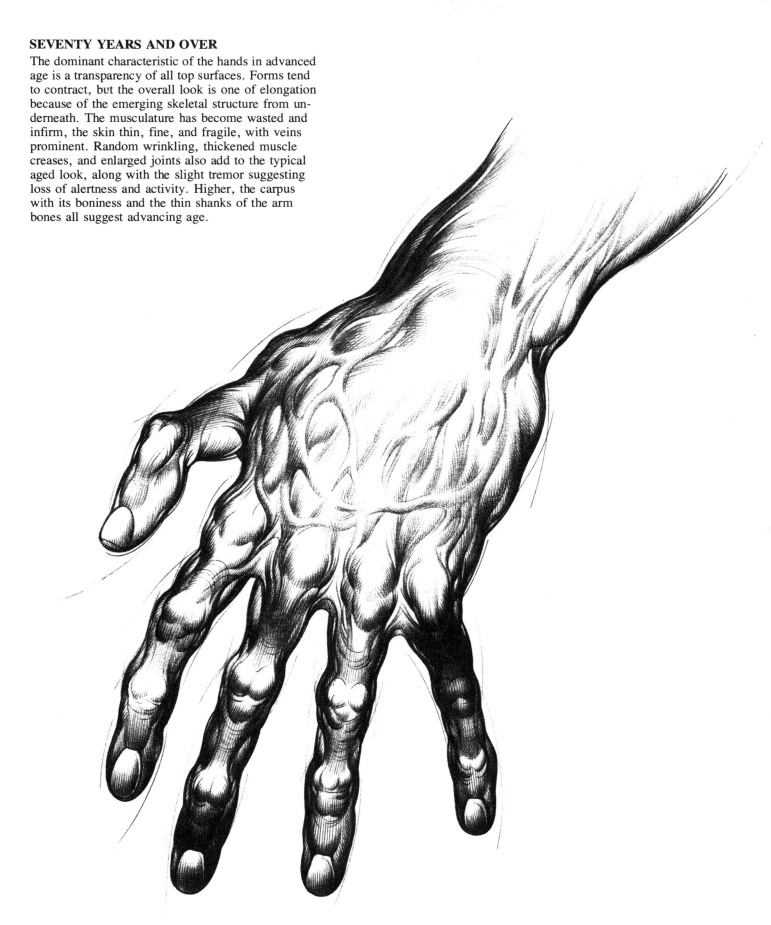

11.
HAND BEHAVIOR AND OCCUPATIONS

Drawing hands involved in various occupations can be either prosaic or exciting. Since the hand is the most plastic part of the anatomy, it can fit around or grasp an infinite variety of shapes in countless positions. Thus an enormous variety of occupations can involve highly complex use of the hands. Occupations often require the use of some kind of utensil or tool to which the hand must adapt itself. The kind of drawing one does of the hand working at various occupations is determined to a great extent by the instrument the hand must use. In this chapter you will see how the element of design plays an important part in executing not only a visually clear but also a visually appealing drawing of the hand involved in an occupation.

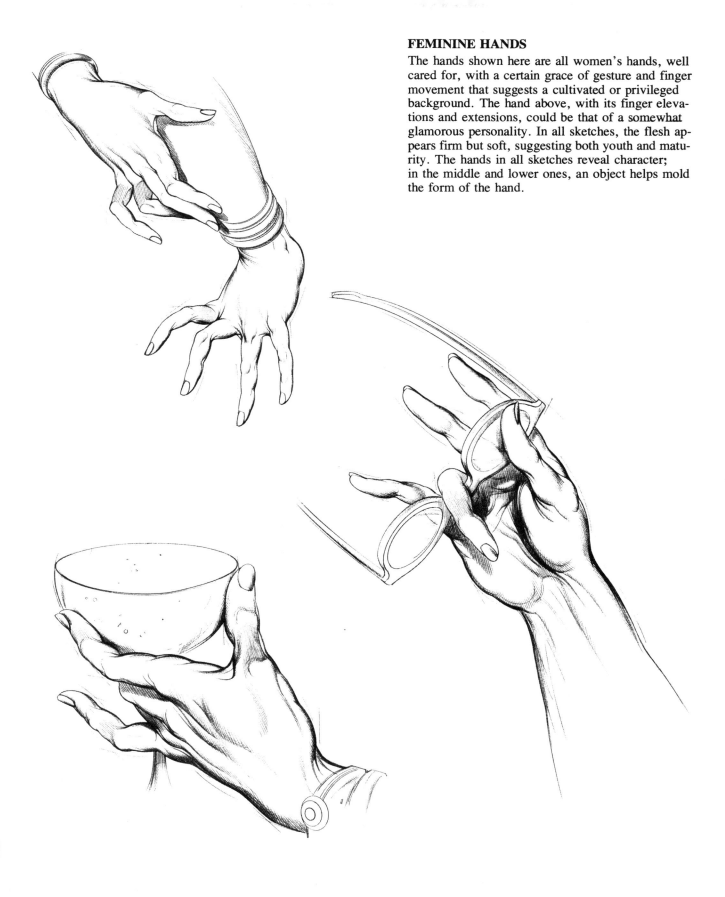

FEMININE HANDS

The hands shown here are all women's hands, well cared for, with a certain grace of gesture and finger movement that suggests a cultivated or privileged background. The hand above, with its finger elevations and extensions, could be that of a somewhat glamorous personality. In all sketches, the flesh appears firm but soft, suggesting both youth and maturity. The hands in all sketches reveal character; in the middle and lower ones, an object helps mold the form of the hand.

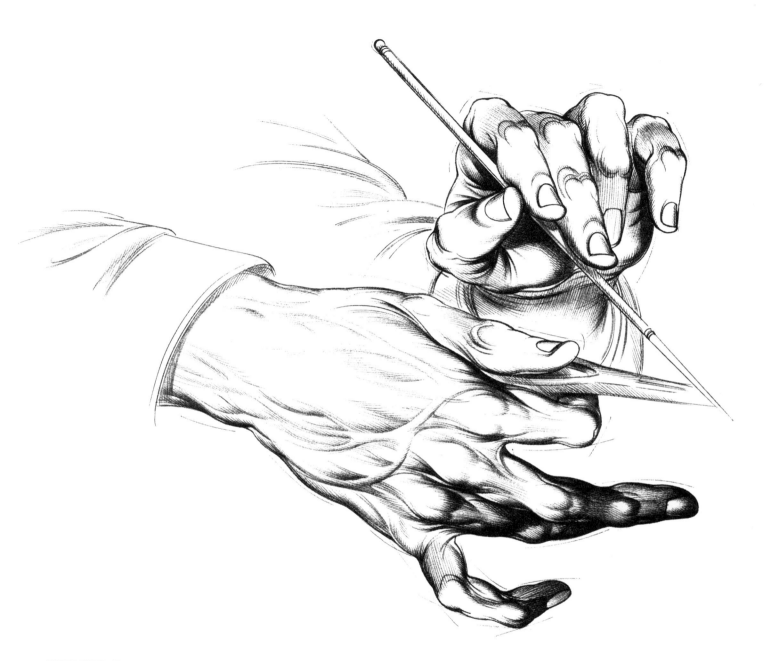

DESIGNING A TECHNICIAN'S HAND

Bringing out the eloquence of a prosaic subject takes
great skill. Here the hands of a technician using
laboratory instruments could become both dull and
difficult. But not if a design concept is incorporated.
In this drawing the focal point of the design is the
instruments connecting at an angle. All the fingers
relate to this angle, and the veins of the lower hand
restate the design theme. Both the lower little finger
pointing toward the vector center and the angle of
the arm follow the dominant direction of the design.

HAND ACTIONS WITH AN INFLEXIBLE OBJECT

In a drawing of a hand held against a hard, unyielding object, the hand is not the primary concern in the initial stage. This sketch illustrates how the hand must relate convincingly to the structure of the guitar, once its position and design have been established. The hands have a special configuration for playing, and a good reference source such as a photograph or a live model should be used to make sure this is accurate before proceeding with drawing refinements such as form stresses, finger tensions, wrist bends, and fingertip contacts and pressures. Shaded accents and cast shadows are also necessary to let the eye see where one form relates to another or to understand the correct positioning of the arm or fingers over the guitar. This drawing is not a finished one. If you feel the need to sketch in more tones or accents, do so.

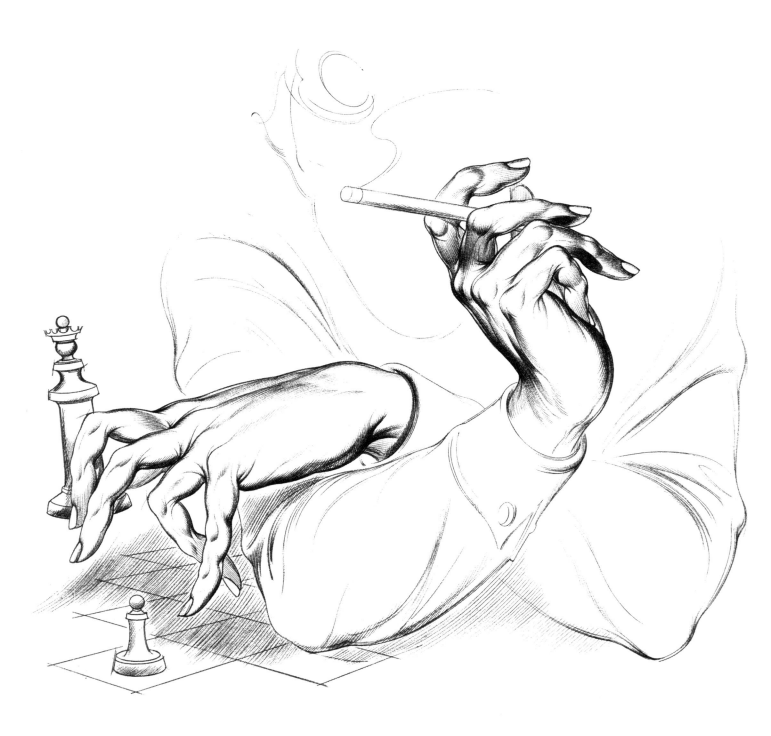

VARIATIONS IN HAND ATTITUDES

The hands of a woman playing chess and pondering a move while smoking a cigarette present a challenging array of possibilities, contrasts, and form contrapositions. The crossed-over hand toying with a chess piece lets both hands create a provocative gesture. The right arm and hand support from below. The reverse direction of the cigarette sends the design flow back to the chess-playing hand. Note that the kinds of open-ended variations shown here are quite different from the constraints demanded by drawing hands playing a guitar.

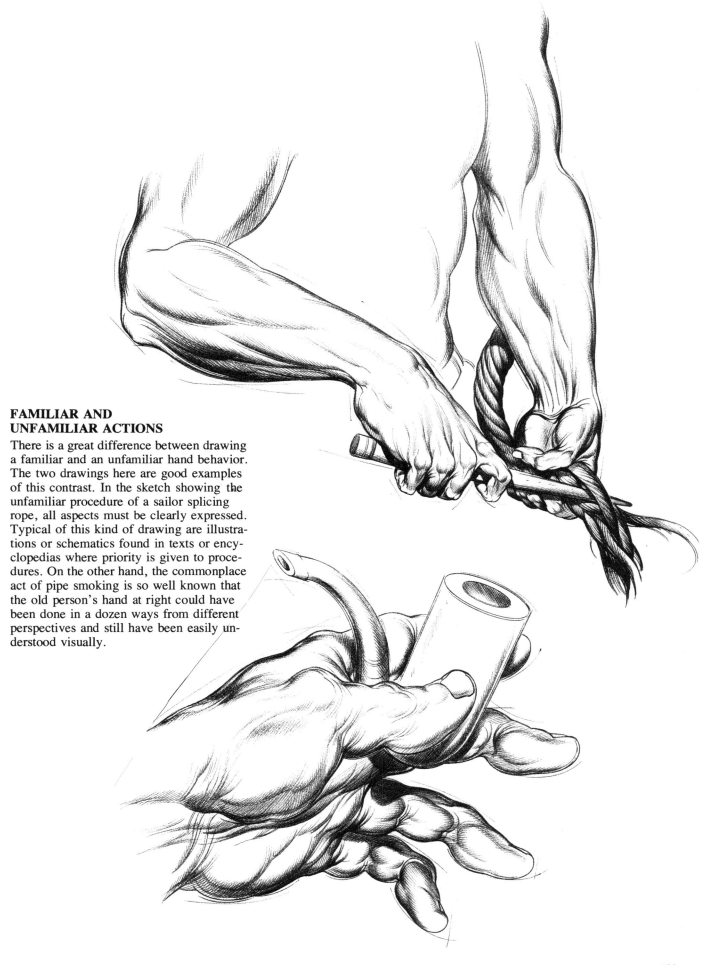

FAMILIAR AND UNFAMILIAR ACTIONS

There is a great difference between drawing a familiar and an unfamiliar hand behavior. The two drawings here are good examples of this contrast. In the sketch showing the unfamiliar procedure of a sailor splicing rope, all aspects must be clearly expressed. Typical of this kind of drawing are illustrations or schematics found in texts or encyclopedias where priority is given to procedures. On the other hand, the commonplace act of pipe smoking is so well known that the old person's hand at right could have been done in a dozen ways from different perspectives and still have been easily understood visually.

FREEDOM AND RESTRICTION IN SUBJECT

Again, the two drawings here are a contrast—this time between the restrictions imposed by an object in the hands and complete freedom. In the drawing at right, the violin restricts hand position and behavior to its configurations. This would also be true for behavior or maneuvers where machines or implements are used. By contrast, the sketch at left is free and playful, and subject to numerous interpretations. Drawing this form allows the imagination free rein and is much less demanding than the one at right.

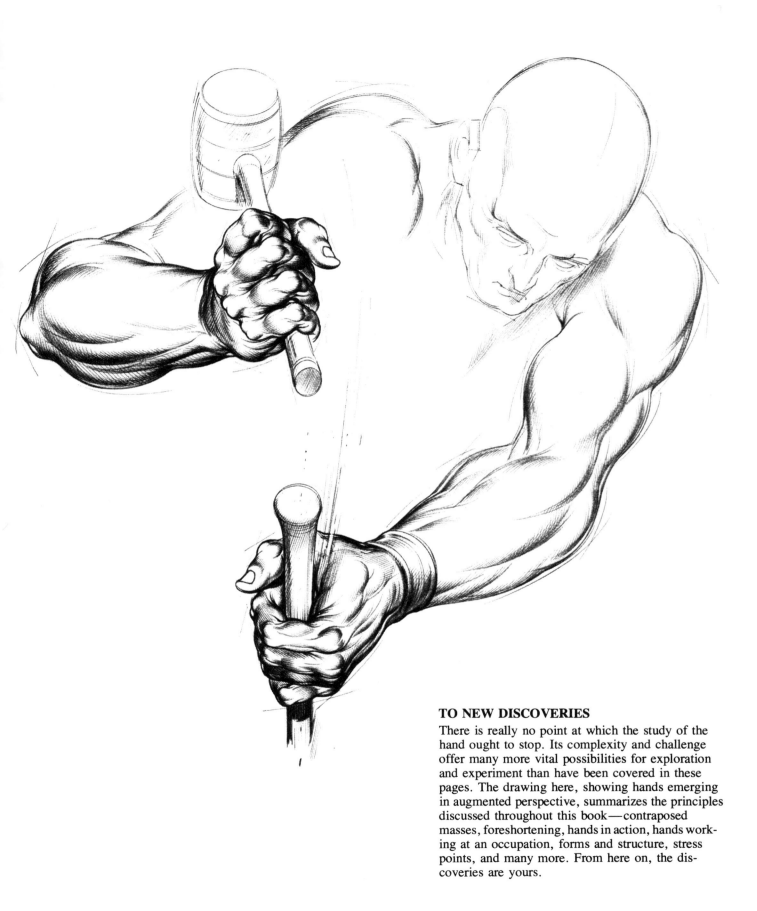

TO NEW DISCOVERIES

There is really no point at which the study of the hand ought to stop. Its complexity and challenge offer many more vital possibilities for exploration and experiment than have been covered in these pages. The drawing here, showing hands emerging in augmented perspective, summarizes the principles discussed throughout this book—contraposed masses, foreshortening, hands in action, hands working at an occupation, forms and structure, stress points, and many more. From here on, the discoveries are yours.

BIBLIOGRAPHY

Anderson, T. McClurg, *Human Kinetics and Analysing Body Movements*. London: William Heinemann Medical Books, 1951.

Brash, J. C., and Jamieson, E. B., *Cunningham's Textbook of Anatomy*. 8th ed. Edinburgh: Oxford University Press, 1943.

Bridgman, George B., *The Book of a Hundred Hands*. New York: Dover, 1962.

Dobkin, Alexander, *Principles of Figure Drawing*. Cleveland, New York: World Publishing, 1948.

Dreyfuss, Henry, *The Measure of Man*. New York: Whitney Library of Design, 1959.

Dunlop, James M., *Anatomical Diagrams*. New York: Macmillan, 1947.

Gettings, Fred, *The Book of the Hand*. Feltham, Middlesex, England: Paul Hamlyn, 1965.

Hatton, Richard C., *Figure Drawing*. London: Chapman and Hall, 1949.

Henninger, Joseph M., *Drawing of the Hand*. Alhambra, Ca.: Borden, 1973.

Hill, Edward, *The Language of Drawing*. Englewood Cliffs, N.J.: Prentice-Hall, 1966.

Lenssen, Heidi, *Hands*. New York, London: Studio Publications, 1949.

Marsh, Reginald, *Anatomy for Artists*. New York: Dover, 1970.

Minor, R. W., *Dynamic Anthropometry*. New York: Annals New York Academy of Sciences, Vol. 63, 1955.

Morath, Adolf, *Children Before My Camera*. Boston: American Photographic Publishing, 1948.

Muybridge, Eadweard, *The Human Figure in Motion*. London: Chapman and Hall, 1931.

Peck, Stephen Rogers, *Atlas of Human Anatomy*. New York: Oxford University Press, 1951.

Perard, Victor, *Anatomy and Drawing*. Victor Perard, 1936.

Priscilla, Louis, *Basic Drawing*. New York: Grayson Publishing, 1954.

Richer, Paul, *Artistic Anatomy*. Translated by Robert Beverly Hale, New York: Watson-Guptill; London: Pitman, 1973.

Sanders, J. B. de C. M., and O'Malley, Charles D., *Vesalius*. Cleveland, New York: World Publishing, 1950.

Shider, Fritz, *An Atlas of Anatomy for Artists*. New York: Dover, 1947.

Singer, Charles, *The Evolution of Anatomy*. London: Knopf, 1925.

Spalteholz, Werner, *Hand Atlas of Human Anatomy*. Philadelphia, London: J. B. Lippincott, 1903.

Thomson, Arthur, *A Handbook of Anatomy for Art Students*. 5th ed. New York: Dover, n.d.

Warring, R. H., *Body Geometry Data*. Englewood, Ca.: Design News, 1957.

Wigg, Philip R., *Introduction to Figure Drawing*. Dubuque, Iowa: William C. Brown, 1967.

INDEX

Edited by Connie Buckley
Designed by Robert Fillie
Composed in 10 point Times Roman by Gerard Associates
Printed and Bound by Interstate Book Manufacturers